D1574033

Point of Purchase
DESIGN ANNUAL

7

THE 42nd MERCHANDISING AWARDS

VISUAL REFERENCE PUBLICATIONS, INC. / NEW YORK

Copyright © 2000 by Visual Reference Publications, Inc.

All rights reserved. No part of this book may be reproduced in any
form or by any electronic mechanical means, including information storage
and retrieval systems, without permission in writing from the publisher.

Visual Reference Publications, Inc.
302 Fifth Avenue
New York, NY 10001

Distributors to the trade in the United States and Canada
Watson-Guptill
1515 Broadway
New York, NY 10036

Distributors outside the United States and Canada
HarperCollins International
10 East 53rd Street
New York, NY 10022-5299

Library of Congress Cataloging in Publication Data:
Main entry under title: Point of Purchase Design Annual No. 7

Printed in Hong Kong
ISBN 1-58471-010-1

Book Design: Bernard Schleifer

CONTENTS

INTRODUCTION 7

MERCHANDISING AWARDS JUDGES 8

DISPLAY OF THE YEAR WINNERS 10

OUTSTANDING MERCHANDISING ACHIEVEMENT AWARDS WINNERS 15

 Beer 16
 Liquor 25
 Cosmetics 35
 Entertainment and Computers 44
 Fragrances 60
 Grocery and General Merchandise Products 65
 Hair and Skin Care 72
 Health Care 82
 Home and Garden 89
 Interactive 98
 Personal Products and Accessories 100
 Retailer Showcase 115
 Services 118
 Snack Products and Soft Drinks 121
 Sports, Toys and Accessories 131
 Stationery, Office Supplies and Seasonal Goods 141
 Tobacco 145
 Transportation 150

MULTINATIONAL CONTEST AWARDS 155

SALES PROMOTION CONTEST AWARDS 161

TECHNICAL ACHIEVEMENT CONTEST AWARDS 164

INDEX 172

DON'T YOU NEED OUR STRENGTH IN YOUR WORLD?

The Point-Of-Purchase Advertising Institute (POPAI) offers brand marketers, retailers and producers and suppliers of point-of-purchase advertising a world of information, networking opportunities and education. Everything they need to do their jobs better and increase their product sales. POPAI, the only international trade association of the in-store marketing industry, also protects and promotes our members' interests on Capitol Hill and around the globe.

THE POPAI MISSION

POPAI is the trade association of the point-of-purchase advertising industry dedicated to serving its more than 1,700 members internationally by promoting, protecting, and advancing the broader interests of point-of-purchase advertising through research, education, trade forums, and legislative efforts. Our purpose is to enable our industry to influence consumers' buying decisions.

THE POPAI VISION
Moving You Ahead

POPAI Members will be knowledgeable, have industry respect and adhere to industry-wide standards. Producer members will be valued by brand marketers, retailers, advertising agencies and others as integral contributors to the advertising mix. Industry practitioners will include the best talent produced by academia and experience.

POPAI will be an Association that has a compendium of information on P-O-P advertising around the world and is viewed as the ultimate source of information on P-O-P. POPAI will have forged global alliances and relationships around the world.

LEARN MORE ABOUT POPAI'S WORLD

Visit us at www.popai.com

INTRODUCTION

WHAT ARE THE POPAI OMA AWARDS

POPAI's Outstanding Merchandising Achievement (OMA) Awards recognize excellence in P-O-P advertising. Entries are judged by a blue-ribbon panel of clients, based on the display's ability to increase sales, obtain retail placements and work strategically to position the brand at the point of sale. For over forty years, the OMA Awards have recognized some of the most effective and original displays that industry has to offer, and is the premier awards recognition program in the P-O-P industry.

Entries are judged in two phases. In phase I, teams of judges review photographs and case histories of the displays in each category and assign preliminary scores. In phase II, the same judges view the actual displays on POPAI's Marketplace show floor and review scores for a final determination of winners.

In honor of their achievement, OMA Award winners receive statuettes which are metal replicas of wooden cigar store Indians that once decorated the entrance of tobacco stores in the early Nineteenth Century. Carved by sailors from salvaged pieces of spars or masts from ships, these wooden figures are America's first known use of three-dimensional P-O-P advertising. Today, POPAI's OMA statuette serves as a symbol of P-O-P's evolution from this modest beginning as a reminder of the intimate connection that P-O-P has always had with consumer products.

The 1999 OMA Awards are comprised of five contests that recognize excellence in P-O-P in different areas:

1. **OMA Contest:** recognizes the excellence of displays produced and placed anywhere in the world.

2. **Multinational Contest:** recognizes the merchandising excellence of displays produced and placed only outside of the United States, Europe and Japan.

3. **Technical Achievement Awards:** recognizes engineering excellence, innovative qualities or a unique solution to a design challenge.

4. **Display of the Year Contest:** recognizes the best in P-O-P advertising. A prestigious Display-of-the Year (D-O-Y) Award is bestowed upon one gold winner in each of the following: Permanent OMA, Temporary OMA, Multinational Contest and the Sales Promotion Contest.

5. **Sales Promotion Contest:** Recognizes the excellence of displays that were part of a national or regional sales promotion from anywhere in the world, and were used in conjunction with at least two additional sales promotion techniques.

Coming in March, 2000: POPAI has added a new signage category! POPAI's Technical Contest returns to Marketplace 2000.

MERCHANDISING AWARDS JUDGES

OMA Contest Judges

Mr. Gunter Alberts
Florsheim Group, Inc.

Ms. Sheila Anderson
Mattel Toys

Mr. Steve Bartolucci, CPP
The Gillette Company/Stationery Products Group

Ms. Susan Bell
Keebler Company

Mr. Matthew Borgard
Barton Beers, Ltd.

Mr. Bob G. Brisky
ICI Paints

Ms. Julie M. Brown
Procter & Gamble, Co.

Mr. Ted A. Brueggemann
Miller Brewing Company

Ms. Nancy Bruner
Kraft Foods

Mr. Jerry Cahee
Dicksons, Inc.

Mr. William David Cook
R. J. Reynolds Tobacco Company

Ms. Jennifer Woomer Dinehart
CornProducts International

Ms. Deborah Doerr
Wm. Wrigley Jr. Co.

Ms. Bea Dorsey
Black & Decker

Mr. Ronald Elowitz
Schering-Plough Health Care Products

Ms. Sandra M. Gallo
Miller Brewing Company

Ms. Arlene S. Gerwin
United Distillers & Vintners (UDVNA)

Ms. Wendy Glancy
Rubbermaid Home Products

Mr. Scott Greenberg
Skechers USA

Mr. Scott Halm
American Greetings Corp.

Ms. Cynthia Harris
Sears Roebuck & Co.

Ms. Hellen Hassler
Kraft Canada, Inc.

Mr. Jay Hawkinson
The Dial Corporation

Ms. Laurie M. Houlihan
L'Oréal Retail Division (A Cosmair Company)

Mr. Carter Hunt
Frito-Lay, Inc.

Mr. Richard Kirwin
Snap-On Tools

Mr. Dennis A. Knaus
Diversified Merchandising Inc.

Mr. Kevin Kramnic
Barton Beers Ltd.

Mr. Stewart Lazares
The Gillette Company

Ms. Andrea L. Martin
E & J Gallo Winery

Ms. Anne Norris
Timex Corp.

Ms. Tina Petro
McCormick & Co.

Mr. Rufus Purnell
Lighthouse Inc.

Ms. JoLynn W. Rogers
Square D Company

Ms. Stephanie Rowbotham
Coca-Cola USA

Mr. James Ruff
Nabisco Biscuit Company

Mr. George A. Rutkowski
B&K Industries Inc.

Mr. Joe Sadtler
M&M/MARS

Mr. John A. Sakaley, III, CPP
Nintendo of America, Inc.

Mr. William L. Smith, Jr.
Procter & Gamble Co.

Mr. Dan Vnencak
Nabisco Biscuit Company

Mr. Michael Wang
Beckett Corporation

Multinational Contest Judges

Mr. Tom Bilinski
United Distillers (Aust.) Ltd.

Mr. Greg Crombie
Glen Oak, Inc./Bossman

Mr. Stephen De Lorenzo
Coca-Cola South Pacific Pty Limited

Ms. Jennifer Dixon
Rothmans Benson & Hedges Inc.

Mr. Serge Durand
Soloman Skis

Ms. Shelly Harrington
Warner Lambert Consumer Healthcare

Ms. Lisa Oversby
Cheltenham and Glouchester Plc.

Mr. Chris Steele
Cheltenham and Gloucester Plc.

Technical Awards Judges

Mr. Herm Buechel
Ivex Packaging Corperation/Colorcor Div.

Mr. Mike Friedman
Trans World Marketing

Ms. Patricia A. Jenkins
Jefferson Smurfit Corporation Display Division

Mr. Brandton W. Romberger
Merchandising Inventives Inc.

Mr. Michael Sarbello
Triangle Container Corporation

Mr. Mark Stanton
Trans World Marketing

Mr. Raymond Stark, Jr.
United States Display Company, Inc.

Mr. Don Ziegler
Prestige Display and Packaging

Display-of-the-Year Judges

Mr. Steve Bartolucci, CPP
The Gillette Company/Stationery Products Group

Ms. Nancy Bruner
Kraft Foods

Mr. Jerry Cahee
Dicksons, Inc.

Ms. Sandra M. Gallo
Miller Brewing Company

Ms. Arlene S. Gerwin
United Distillers & Vintners (UDVNA)

Mr. Jay Hawkinson
The Dial Corporation

Mr. Richard Kirwin
Snap-On Tools

Ms. Andrea L. Martin
E & J Gallo Winery

Mr. Joe Sadtler
M&M/MARS

Mr. John A. Sakaley, III, CPP
Nintendo of America, Inc.

Mr. William L. Smith, Jr.
Procter & Gamble Co.

DISPLAY OF THE YEAR CONTEST WINNERS

10 / Display of the Year Winners

TEMPORARY DISPLAY OF THE YEAR WINNER

TITLE
Ecco Domani Wire Woman
Mass Merchandiser

CLIENT
E & J Gallo Winery

ENTRANT
Rack's Inc.
San Diego, CA

OBJECTIVES
To market Ecco Domani as being stylish, chic, and a break from traditional thinking in the wine industry.

MATERIALS
1/0, #3, #6, and #11 wire, 1" round metal tubing, 1 four-color header, 1 two-color decal.

Display of the Year Winners / 11

Semi-Permanent Display of the Year Winner

Title
Rouge Pulp Wal-Mart 4-Way

Client
L'Oréal Retail Division

Entrant
Ultimate Display Industries
Jamaica, NY

Objectives
To introduce L'Oréal's new product: Rouge Pulp anti-feathering lip liner; to introduce 13 new shades of Rouge Pulp Liquid Lipcolour' to achieve incremental volume and encourage multiple purchases.

Materials
Thermoformed styrene, corrugate, metal brackets, rubber plate printing, hot stamping, silkscreening.

12 / Display of the Year Winners

MULTINATIONAL DISPLAY OF THE YEAR WINNER

TITLE
Tylenol Rotating Floor Display

CLIENT
McNeil Consumer Products

ENTRANT
Point 1 Displays, Inc.
Montreal, Quebec, Canada

OBJECTIVES
To develop a floor display that would create and reinforce a strong product image. Each gravity fed cube represents a distinct product class.

MATERIALS
Fabricated Styrene, Injection Molded Turntable, PETG.

Display of the Year Winners / 13

Sales Promotion Display of the Year Winner

Title
Miller Lite Football

Client
Miller Brewing Company

Entrant
Miller Brewing Company
Milwaukee, WI

Objectives
Develop a promotion that maintains Lite's close association with football, meets retailers expectations, and creates display and purchase continuity across the entire football season using established brand equities and tie-in partners.

Materials
Materials used were display cards, case cards, table tents, banners, string pennants, static stickers, base wrap, aisle spanners floor graphics, outdoor inflatables, metal tackers, and many different premiums.

Display of the Year Winners

PERMANENT DISPLAY OF THE YEAR WINNER

TITLE
Camel CTS Program

CLIENT
R. J. Reynolds Tobacco Co.

ENTRANT
Trans World Marketing
East Rutherford, NJ

OBJECTIVES
The kiosk capitalizes on the strong equity that Camel has established throughout its history as one of the nation's most popular cigarette brands. It is designed to make a contemporary, powerful brand statement.

MATERIALS
Laminated MDF, fabricated wire, metal and plastic extrusions, fabricated acrylic, metal tubing, vacuum forming and roll number pricing, as well as halogen, incandescent and fluorescent lighting techniques.

OUTSTANDING MERCHANDISING ACHIEVEMENT AWARDS CONTEST

The OMA Contest recognizes the merchandising excellence of displays produced and placed anywhere in the world.

16 / Beer

Award
Gold

Title
Budweiser Spectacular

Client
Anheuser-Busch, Inc.

Entrant
Rapid Displays
Chicago, IL

Sub-Category
Off-Premise - Non-Illuminated or Non-Motion

Division
Temporary

Award
Gold

Title
Sol Cerveza "Use Your Cabeza" Neck Hanger

Client
Labatt USA

Entrant
The Marketing Continuum, Inc.
Dallas, TX

Sub-Category
Off-Premise - Non-Illuminated or Non-Motion

Division
Temporary

Award
Gold

Title
Icehouse Fish 3-D Wall Sign

Client
Miller Brewing Company

Entrant
MoldRite Products, Inc.
Waukesha, WI

Sub-Category
On-Premise - Non-Illuminated or Non-Motion

Division
Permanent

Beer / 17

AWARD
Gold

TITLE
MGD Menu Board with Overhead Light

CLIENT
Miller Brewing Company

ENTRANT
Trans World Marketing
East Rutherford, NJ

SUB-CATEGORY
On-Premise - Illuminated or Motion

DIVISION
Permanent

AWARD
Silver

TITLE
Budweiser Lizard Cooler Door Sign

CLIENT
Anheuser-Busch, Inc.

ENTRANT
Everbrite, Inc.
Greenfield, WI

SUB-CATEGORY
Off-Premise - Illuminated or Motion

DIVISION
Semi-Permanent

AWARD
Silver

TITLE
Casa De Corona Pool Table Lamp

CLIENT
Barton Beers Ltd.

ENTRANT
KCS Industries, Inc.
Hartland, WI

SUB-CATEGORY
On-Premise - Illuminated or Motion

DIVISION
Permanent

18 / Beer

AWARD
Silver

TITLE
Samuel Adams Summer Ale Sailboat

CLIENT
Boston Beer Company

ENTRANT
Ruszel Woodworks, Inc.
Benicia, CA

SUB-CATEGORY
Off-Premise - Non-Illuminated or Non-Motion

DIVISION
Temporary

AWARD
Silver

TITLE
Coors Light Cow Skull Tap Knob

CLIENT
Coors Brewing Company

ENTRANT
The Integer Group
Lakewood, CO

SUB-CATEGORY
On-Premise - Non-Illuminated or Non-Motion

DIVISION
Permanent

AWARD
Silver

TITLE
Coors Light Changing-Label Lighted Sign

CLIENT
Coors Brewing Company

ENTRANT
The Integer Group
Lakewood, CO

SUB-CATEGORY
Off-Premise - Illuminated or Motion

DIVISION
Permanent

AWARD
Silver

TITLE
Lite Miller Time with Tracing Lights Sign

CLIENT
Miller Brewing Company

ENTRANT
KCS Industries, Inc.
Hartland, WI

SUB-CATEGORY
On-Premise - Illuminated or Motion

DIVISION
Permanent

Beer / 19

AWARD
Silver

TITLE
Foster's How to Speak Australian

CLIENT
Miller Brewing Company

ENTRANT
Miller Brewing Company
Milwaukee, WI

SUB-CATEGORY
On-Premise - Non-Illuminated or Non-Motion

DIVISION
Temporary

AWARD
Silver

TITLE
IceHouse Brew Kettle Pool Table Lamp

CLIENT
Plank Road Brewery

ENTRANT
KCS Industries, Inc.
Hartland, WI

SUB-CATEGORY
On-Premise - Illuminated or Motion

DIVISION
Permanent

AWARD
Bronze

TITLE
Bud Racing

CLIENT
Anheuser-Busch, Inc.

ENTRANT
Anheuser-Busch, Inc.
St. Louis, MO

SUB-CATEGORY
Off-Premise - Non-Illuminated or Non-Motion

DIVISION
Permanent

20 / Beer

AWARD
Bronze

TITLE
Michelob Family Holiday Fireplace Spectacular

CLIENT
Anheuser-Busch, Inc.

ENTRANT
Phoenix Display, A Union Camp Company
West Deptford, NJ

SUB-CATEGORY
Off-Premise - Non-Illuminated or Non-Motion

DIVISION
Temporary

AWARD
Bronze

TITLE
Samuel Adams "Best of the Season" Program

CLIENT
Boston Beer Company

ENTRANT
C.D. Baird & Co., Inc.
West Allis, WI

SUB-CATEGORY
Off-Premise - Illuminated or Motion

DIVISION
Temporary

AWARD
Bronze

TITLE
Coors Light Dominator Neon

CLIENT
Coors Brewing Company

ENTRANT
The Integer Group
Lakewood, CO

SUB-CATEGORY
On-Premise - Illuminated or Motion

DIVISION
Permanent

Beer / 21

AWARD
Bronze

TITLE
Rolling Rock "Free Works of Art" Promotion

CLIENT
Labatt USA Inc.

ENTRANT
The Marketing Continuum, Inc.
Dallas, TX

SUB-CATEGORY
On-Premise - Non-Illuminated or Non-Motion

DIVISION
Semi-Permanent

AWARD
Bronze

TITLE
Killian's Horsehead Display Rack

CLIENT
Coors Brewing Company

ENTRANT
The Integer Group
Lakewood, CO

SUB-CATEGORY
On-Premise - Non-Illuminated or Non-Motion

DIVISION
Permanent

AWARD
Bronze

TITLE
Lite Holiday Village Spectacular

CLIENT
Miller Brewing Company

ENTRANT
C.D. Baird & Co., Inc.
West Allis, WI

SUB-CATEGORY
Off-Premise - Illuminated or Motion

DIVISION
Temporary

22 / Beer

AWARD
Bronze

TITLE
Molson Prestige Neon

CLIENT
Miller Brewing Company

ENTRANT
Everbrite, Inc.
Greenfield, WI

SUB-CATEGORY
On-Premise - Illuminated or Motion

DIVISION
Permanent

AWARD
Bronze

TITLE
Miller Genuine Draft Carton Game Table Lamp

CLIENT
Miller Brewing Company

ENTRANT
Great Northern Corporation
Racine, WI

SUB-CATEGORY
On-Premise - Illuminated or Motion

DIVISION
Permanent

AWARD
Bronze

TITLE
Miller High Life Soft Cross Neon

CLIENT
Miller Brewing Company

ENTRANT
Fallon Luminous Products Corporation
Spartanburg, SC

SUB-CATEGORY
Off-Premise - Illuminated or Motion

DIVISION
Permanent

Beer / 23

AWARD
Bronze

TITLE
Molson Holiday

CLIENT
Miller Brewing Company

ENTRANT
Miller Brewing Company
Milwaukee, WI

SUB-CATEGORY
Off-Premise - Non-Illuminated or Non-Motion

DIVISION
Temporary

AWARD
Bronze

TITLE
MGD Drink Caddy

CLIENT
Miller Brewing Company

ENTRANT
Trans World Marketing
East Rutherford, NJ

SUB-CATEGORY
On-Premise - Non-Illuminated or Non-Motion

DIVISION
Permanent

AWARD
Bronze

TITLE
Lite Ceiling Logo

CLIENT
Miller Brewing Company

ENTRANT
Trans World Marketing
East Rutherford, NJ

SUB-CATEGORY
Off-Premise - Non-Illuminated or Non-Motion

DIVISION
Permanent

24 / Beer

Award
Bronze

Title
Lite Spring Clip

Client
Miller Brewing Company

Entrant
Trans World Marketing
East Rutherford, NJ

Sub-Category
On-Premise - Illuminated or Motion

Division
Permanent

Award
Bronze

Title
Rolling Rock Bottle Neon

Client
The Marketing Continuum Inc.

Entrant
Everbrite, Inc.
Greenfield, WI

Sub-Category
Off-Premise - Illuminated or Motion

Division
Permanent

Award
Bronze

Title
Coors Talking Can Promotion

Client
The Campbell Group Ltd.

Entrant
Chesapeake Display and Packaging, Inc.
Winston-Salem, NC

Sub-Category
On-Premise - Non-Illuminated or Non-Motion

Division
Temporary

Liquor / 25

AWARD
Gold

TITLE
Tropico By Bacardi Display

CLIENT
Bacardi Martini

ENTRANT
Bish Creative Display
Lake Zurich, IL

SUB-CATEGORY
Distilled Spirits -
Non-Illuminated or Non-Motion

DIVISION
Permanent

AWARD
Gold

TITLE
Hornsby's Rhino Mass Display

CLIENT
E & J Gallo Winery

ENTRANT
Bert-Co Graphics
Pleasanton, CA

SUB-CATEGORY
Cordials and Wines

DIVISION
Temporary

AWARD
Gold

TITLE
Ecco Domani Wire Woman
Mass Merchandiser

CLIENT
E & J Gallo Winery

ENTRANT
Rack's, Inc.
San Diego, CA

SUB-CATEGORY
Cordials and Wines

DIVISION
Temporary

26 / Liquor

AWARD
Gold

TITLE
Ocumare Back Bar

CLIENT
Schieffelin & Somerset Co.

ENTRANT
Flair Display
Bronx, NY

SUB-CATEGORY
Distilled Spirits -
Non-Illuminated or Non-Motion

DIVISION
Permanent

AWARD
Silver

TITLE
Cook's Champagne Holiday
Motion Display

CLIENT
Canandaigua Wine Company

ENTRANT
Baer Enterprises
Livermore, CA

SUB-CATEGORY
Cordials and Wines

DIVISION
Temporary

AWARD
Silver

TITLE
Beefeater Motion Pole Topper

CLIENT
Diamond Group

ENTRANT
U.S. Display Co., Inc.
Hawk Point, MO

SUB-CATEGORY
Distilled Spirits - Illuminated
or Motion

DIVISION
Temporary

Liquor / 27

AWARD
Silver

TITLE
Kahlua Arch Display Floor Unit

CLIENT
Hiram Walker & Sons, Inc.

ENTRANT
Westcott Displays
Detroit, MI

SUB-CATEGORY
Distilled Spirits -
Non-Illuminated or Non-Motion

DIVISION
Semi-Permanent

AWARD
Silver

TITLE
Ocumare Counter Display

CLIENT
Schieffelin & Somerset Co.

ENTRANT
Flair Display
Bronx, NY

SUB-CATEGORY
Distilled Spirits -
Non-Illuminated or Non-Motion

DIVISION
Permanent

AWARD
Silver

TITLE
Dom Perignon

CLIENT
Schieffelin & Somerset Co.

ENTRANT
Flair Display
Bronx, NY

SUB-CATEGORY
Cordials and Wines

DIVISION
Permanent

28 / Liquor

AWARD
Silver

TITLE
Richard Hennessy Lighted Glorifier

CLIENT
Schieffelin & Somerset Co.

ENTRANT
Flair Display
Bronx, NY

SUB-CATEGORY
Distilled Spirits - Illuminated or Motion

DIVISION
Permanent

AWARD
Silver

TITLE
Ocumare Floor Display

CLIENT
Schieffelin & Somerset Co.

ENTRANT
Flair Display
Bronx, NY

SUB-CATEGORY
Distilled Spirits - Non-Illuminated or Non-Motion

DIVISION
Permanent

AWARD
Bronze

TITLE
Canadian Club Portfolio Back Bar Pedestal

CLIENT
Allied Domecq Spirits, USA

ENTRANT
Flair Communications Agency, Inc.
Chicago, IL

SUB-CATEGORY
Distilled Spirits - Illuminated or Motion

DIVISION
Permanent

Liquor / 29

AWARD
Bronze

TITLE
Bacardi Shots Motion Sign

CLIENT
Bacardi Martini Promotions

ENTRANT
Heritage Frame & Glass Creations, Ltd.
Nesquehoning, PA

SUB-CATEGORY
Distilled Spirits - Illuminated or Motion

DIVISION
Permanent

AWARD
Bronze

TITLE
Fine Wine/Cigar Cross Merchandiser

CLIENT
Chateau Ste. Michelle Winery

ENTRANT
Ruszel Woodworks, Inc.
Benicia, CA

SUB-CATEGORY
Cordials and Wines

DIVISION
Permanent

AWARD
Bronze

TITLE
Bolla Grape Cluster 7 Case Wire Rack

CLIENT
Brown-Forman Beverages Worldwide

ENTRANT
Rack's Inc.
San Diego, CA

SUB-CATEGORY
Cordials and Wines

DIVISION
Permanent

30 / Liquor

AWARD
Bronze

TITLE
Finlandia Melting Glacier Display

CLIENT
Creative Alliance

ENTRANT
MBH Presentations, Inc.
Floral Park, NY

SUB-CATEGORY
Distilled Spirits - Illuminated or Motion

DIVISION
Semi-Permanent

AWARD
Bronze

TITLE
Jack Daniel's Holiday Case Display

CLIENT
Draft Worldwide

ENTRANT
Rapid Displays
Chicago, IL

SUB-CATEGORY
Distilled Spirits - Non-Illuminated or Non-Motion

DIVISION
Temporary

AWARD
Bronze

TITLE
Jack Daniel's Holiday Pole Display

CLIENT
Draft Worldwide

ENTRANT
Rapid Displays
Chicago, IL

SUB-CATEGORY
Distilled Spirits - Illuminated or Motion

DIVISION
Temporary

Liquor / 31

AWARD
Bronze

TITLE
Kahlua Holiday Motion Display

CLIENT
Flair Communications

ENTRANT
Westcott Displays
Detroit, MI

SUB-CATEGORY
Distilled Spirits - Illuminated or Motion

DIVISION
Semi-Permanent

AWARD
Bronze

TITLE
Defenders Of The Malt

CLIENT
Hiram Walker & Sons, Inc.

ENTRANT
Flair Display
Bronx, NY

SUB-CATEGORY
Distilled Spirits - Non-Illuminated or Non-Motion

DIVISION
Permanent

AWARD
Bronze

TITLE
Kahlua Generic Step Bin With Case Card

CLIENT
Hiram Walker & Sons, Inc.

ENTRANT
Westcott Displays
Detroit, MI

SUB-CATEGORY
Distilled Spirits - Non-Illuminated or Non-Motion

DIVISION
Semi-Permanent

32 / Liquor

AWARD
Bronze

TITLE
Black & White Back Bar Glorifier

CLIENT
Jim Beam Brands

ENTRANT
The Niven Marketing Group
Bensenville, IL

SUB-CATEGORY
Distilled Spirits -
Non-Illuminated or Non-Motion

DIVISION
Permanent

AWARD
Bronze

TITLE
Open Up Bolla Pole Display

CLIENT
PriceWeber Marketing
Communications, Inc.

ENTRANT
Rapid Displays
Chicago, IL

SUB-CATEGORY
Cordials and Wines

DIVISION
Semi-Permanent

AWARD
Bronze

TITLE
DeKuyper Pucker's Floor Display

CLIENT
Jim Beam Brands

ENTRANT
The Niven Marketing Group
Bensenville, IL

SUB-CATEGORY
Cordials and Wines

DIVISION
Permanent

Liquor / 33

AWARD
Bronze

TITLE
Hennessy Flight Tray

CLIENT
Schieffelin & Somerset Co.

ENTRANT
Acrylic Designs Inc.
Springfield, VT

SUB-CATEGORY
Distilled Spirits -
Non-Illuminated or Non-Motion

DIVISION
Permanent

AWARD
Bronze

TITLE
Citraz Glorifier

CLIENT
Schieffelin & Somerset Co.

ENTRANT
Flair Display
Bronx, NY

SUB-CATEGORY
Distilled Spirits - Illuminated or Motion

DIVISION
Permanent

AWARD
Bronze

TITLE
The VO Gold Floorstand

CLIENT
Siebel Marketing Group

ENTRANT
Consumer Promotions International
Mount Vernon, NY

SUB-CATEGORY
Distilled Spirits -
Non-Illuminated or Non-Motion

DIVISION
Permanent

34 / Liquor

AWARD
Bronze

TITLE
Skyy Floor Display

CLIENT
Skyy Vodka Spirits, Inc.

ENTRANT
Flair Display
Bronx, NY

SUB-CATEGORY
Distilled Spirits -
Non-Illuminated or Non-Motion

DIVISION
Permanent

AWARD
Bronze

TITLE
Multibrand Summer Drink
Center End Aisle

CLIENT
UDV North America

ENTRANT
U.S. Display Co., Inc.
Hawk Point, MO

SUB-CATEGORY
Distilled Spirits -
Non-Illuminated or Non-Motion

DIVISION
Temporary

AWARD
Bronze

TITLE
Glen Ellen Wine Spectacular

CLIENT
United Distillers Vintner -
Glen Ellen

ENTRANT
Phoenix Display,
A Union Camp Company
West Deptford, NJ

SUB-CATEGORY
Cordials and Wines

DIVISION
Temporary

Cosmetics / 35

AWARD
Gold

TITLE
Trend Display–Cover Girl P&G

CLIENT
Cover Girl–Procter and Gamble

ENTRANT
IDMD Manufacturing, Inc.
Toronto, ON, Canada

SUB-CATEGORY
Multiple Product Line
Merchandisers

DIVISION
Permanent

AWARD
Gold

TITLE
The Estée Lauder "Raincoat"
Counter Unit

CLIENT
Estée Lauder, Inc.

ENTRANT
Consumer Promotions International
Mount Vernon, NY

SUB-CATEGORY
Multiple Product Line
Merchandisers

DIVISION
Semi-Permanent

AWARD
Gold

TITLE
Rouge Pulp Wal-Mart 4-Way

CLIENT
L'Oréal Retail Division

ENTRANT
Ultimate Display Industries
Jamaica, NY

SUB-CATEGORY
Single Product Line
Merchandisers

DIVISION
Semi-Permanent

36 / Cosmetics

Award
Gold

Title
L'Oréal Spring Shade "Elements" Counter

Client
L'Oréal, Inc.

Entrant
Display Producers, Inc.
Bronx, NY

Sub-Category
Multiple Product Line Merchandisers

Division
Semi-Permanent

Award
Gold

Title
Streetwear Refrigerator

Client
Revlon, Inc.

Entrant
Advertising Display Company
Lyndhurst, NJ

Sub-Category
Multiple Product Line Merchandisers

Division
Temporary

Award
Gold

Title
Tony & Tina Lipstick Display

Client
Tony & Tina

Entrant
The Royal Promotion Group
New York, NY

Sub-Category
Single Product Line Merchandisers

Division
Permanent

Cosmetics / 37

AWARD
Silver

TITLE
Lash Luxe Tester/Mascara Merchandiser -Estée Lauder

CLIENT
Estée Lauder, Inc.

ENTRANT
IDMD Manufacturing, Inc.
Toronto, ON Canada

SUB-CATEGORY
Single Product Line Merchandisers

DIVISION
Permanent

AWARD
Silver

TITLE
Mural Maquillage Chanel

CLIENT
Chanel

ENTRANT
Diam Groupe
Les Mure aux France,
France

SUB-CATEGORY
Multiple Product Line Merchandisers

DIVISION
Permanent

AWARD
Silver

TITLE
Futurist Lipstick Tester - Estée Lauder

CLIENT
Estée Lauder, Inc.

ENTRANT
IDMD Manufacturing, Inc.
Toronto, ON, Canada

SUB-CATEGORY
Testers

DIVISION
Semi-Permanent

AWARD
Silver

TITLE
L'Oréal Le Grand Curl Mascara Wal-Mart 4-Way

CLIENT
L'Oréal Retail Division

ENTRANT
Ultimate Display Industries
Jamaica, NY

SUB-CATEGORY
Single Product Line Merchandisers

DIVISION
Semi-Permanent

38 / Cosmetics

AWARD
Silver

TITLE
Almay Transformers Modular C/D

CLIENT
Revlon, Inc.

ENTRANT
Advertising Display Company
Lyndhurst, NJ

SUB-CATEGORY
Multiple Product Line Merchandisers

DIVISION
Semi-Permanent

AWARD
Silver

TITLE
Smashbox Cosmetic Testers

CLIENT
Smashbox Studio Cosmetics

ENTRANT
The Royal Promotion Group
New York, NY

SUB-CATEGORY
Testers

DIVISION
Permanent

AWARD
Bronze

TITLE
Lancôme Summer '98 "Color Story"

CLIENT
Cosmair, Inc.

ENTRANT
P.O.P. Displays, International
Woodside, NY

SUB-CATEGORY
Testers

DIVISION
Semi-Permanent

Cosmetics / 39

AWARD
Bronze

TITLE
Jean Coutu Floor Stand–
Cover Girl P&G

CLIENT
Cover Girl–Procter and Gamble

ENTRANT
IDMD Manufacturing, Inc.
Toronto, ON, Canada

SUB-CATEGORY
Multiple Product Line
Merchandisers

DIVISION
Permanent

AWARD
Bronze

TITLE
Estée Lauder Indelible
Lipstick Display

CLIENT
Estée Lauder, Inc.

ENTRANT
Consumer Promotions
International
Mount Vernon, NY

SUB-CATEGORY
Single Product Line
Merchandisers

DIVISION
Permanent

AWARD
Bronze

TITLE
Estée Lauder Lipstick Tower

CLIENT
Estée Lauder, Inc.

ENTRANT
Display Producers, Inc.
Bronx, NY

SUB-CATEGORY
Testers

DIVISION
Permanent

40 / Cosmetics

Award
Bronze

Title
Double Wear Foundation
Tester–Estée Lauder

Client
Estée Lauder, Inc.

Entrant
IDMD Manufacturing, Inc.
Toronto, ON, Canada

Sub-Category
Testers

Division
Semi-Permanent

Award
Bronze

Title
L'Oréal Jet Set Nail Wal-Mart 4-Way

Client
L'Oréal Retail Division

Entrant
Ultimate Display Industries
Jamaica, NY

Sub-Category
Multiple Product Line
Merchandisers

Division
Semi-Permanent

Award
Bronze

Title
Laura Mercier Tester

Client
Kusin Gurwitch Cosmetics, LLC.

Entrant
P.O.P. Displays, International
Woodside, NY

Sub-Category
Testers

Division
Permanent

Cosmetics / 41

Award
Bronze

Title
L'Oréal Le Grand Curl
Mascara Counter

Client
L'Oréal, Inc.

Entrant
Display Producers, Inc.
Bronx, NY

Sub-Category
Single Product Line
Merchandisers

Division
Semi-Permanent

Award
Bronze

Title
Maybelline Cosmic Edge
Collection

Client
Maybelline Inc.

Entrant
Ultimate Display Industries
Jamaica, NY

Sub-Category
Multiple Product Line
Merchandisers

Division
Temporary

Award
Bronze

Title
Parfums Givenchy Tester/Glorifier

Client
Parfums Givenchy

Entrant
P.O.P. Displays, International
Woodside, NY

Sub-Category
Testers

Division
Permanent

Award
Bronze

Title
Maybelline Wondercurl
Floor Display

Client
Maybelline Canada

Entrant
Techno P.O.S., Inc.
Anjou, Quebec, Canada

Sub-Category
Single Product Line
Merchandisers

Division
Temporary

42 / Cosmetics

AWARD
Bronze

TITLE
Max Factor Beauty Expert Center

CLIENT
Procter & Gamble Co.

ENTRANT
Alliance Display
Winston-Salem, NC

SUB-CATEGORY
Testers

DIVISION
Semi-Permanent

AWARD
Bronze

TITLE
Ellen Betrix Gondola Merchandiser

CLIENT
Procter & Gamble GMBH

ENTRANT
Diam International
Leicester, England

SUB-CATEGORY
Single Product Line Merchandisers

DIVISION
Permanent

AWARD
Bronze

TITLE
Oil of Olay Showcase Merchandising Unit

CLIENT
Procter & Gamble Co.

ENTRANT
RTC Industries, Inc.
Rolling Meadows, IL

SUB-CATEGORY
Multiple Product Line Merchandisers

DIVISION
Permanent

Cosmetics / 43

AWARD
Bronze

TITLE
Brazen Berry Refrigerator

CLIENT
Revlon, Inc.

ENTRANT
Advertising Display Company
Lyndhurst, NJ

SUB-CATEGORY
Multiple Product Line
Merchandisers

DIVISION
Semi-Permanent

AWARD
Bronze

TITLE
Almay Stay Smooth Lip Display

CLIENT
Revlon, Inc.

ENTRANT
Promotional Development
Brooklyn, NY

SUB-CATEGORY
Single Product Line
Merchandisers

DIVISION
Permanent

AWARD
Bronze

TITLE
Tesco Make Merchandiser

CLIENT
Tesco Stores PLC

ENTRANT
Diam International
Leicester, England

SUB-CATEGORY
Multiple Product Line
Merchandisers

DIVISION
Permanent

44 / Entertainment and Computers

AWARD
Gold

TITLE
Dr. Dolittle Video Standee and Mobile

CLIENT
20th Century Fox

ENTRANT
Cornerstone Display Group, Inc.
San Fernando, CA

SUB-CATEGORY
Movies, Tapes, Records, CDs

DIVISION
Temporary

AWARD
Gold

TITLE
Tiger Woods EA Sports Display

CLIENT
Electronic Arts

ENTRANT
Santa Cruz Industries
Santa Cruz, CA

SUB-CATEGORY
Home Entertainment -
Non-Interactive, Non-Motion or
Non-Illuminated

DIVISION
Semi-Permanent

AWARD
Gold

TITLE
(Miniature) Perm. School
House/Bus Display

CLIENT
Havas Interactive, Inc.

ENTRANT
Justman Packaging & Display
Los Angeles, CA

SUB-CATEGORY
Computer Software

DIVISION
Permanent

Entertainment and Computers / 45

Award
Gold

Title
Barney's Halloween Treat House

Client
Lyrick Studios

Entrant
Phoenix Display,
A Union Camp Company
West Deptford, NJ

Sub-Category
Movies, Tapes, Records, CDs

Division
Temporary

Award
Gold

Title
Microsoft Sound System 80 Int'l Demonstrator

Client
Microsoft Corporation

Entrant
Schutz International, Inc.
Morton Grove, IL

Sub-Category
Computer Hardware

Division
Permanent

Award
Gold

Title
JVC Cybercam Display

Client
JVC Company of America

Entrant
United Displaycraft
Des Plaines, IL

Sub-Category
Home Entertainment - Interactive, Motion or Illuminated

Division
Permanent

Award
Gold

Title
Wizard of Oz Display

Client
Warner Bros.

Entrant
Drissi Advertising, Inc.
Los Angeles, CA

Sub-Category
Movies, Tapes, Records, CDs

Division
Semi-Permanent

46 / Entertainment and Computers

AWARD
Silver

TITLE
Intensor Demonstrator

CLIENT
Blau Marketing

ENTRANT
Thomson-Leeds Company, Inc.
New York, NY

SUB-CATEGORY
Home Entertainment -
Interactive, Motion or Illuminated

DIVISION
Permanent

AWARD
Silver

TITLE
iMac Tower with Mouse
Pad Base

CLIENT
CKS Partners

ENTRANT
Rapid Displays
Union City, CA

SUB-CATEGORY
Computer Hardware

DIVISION
Semi-Permanent

AWARD
Silver

TITLE
Epson Product Demonstrator

CLIENT
Epson America

ENTRANT
Trans World Marketing
East Rutherford, NJ

SUB-CATEGORY
Computer Hardware

DIVISION
Permanent

Entertainment and Computers / 47

Award
Silver

Title
Rudolph Modular Pallet Program

Client
Goodtimes Entertainment

Entrant
Triangle Display Group
Philadelphia, PA

Sub-Category
Movies, Tapes, Records, CDs

Division
Temporary

Award
Silver

Title
Diamond Multimedia Monter 3DII Display

Client
Keene Communications

Entrant
Smurfit-Stone Display Group/Cundell Corrugate
Chelmsford, Essex, England

Sub-Category
Computer Hardware

Division
Temporary

Award
Silver

Title
WIN 98 Launch Semi-Permanent Floor Display

Client
Microsoft Corporation

Entrant
Rapid Displays
Union City, CA

Sub-Category
Computer Software

Division
Semi-Permanent

48 / Entertainment and Computers

Award
Silver

Title
Color Game Boy Tether Interactive Display

Client
Nintendo of America, Inc

Entrant
Frank Mayer & Associates, Inc.
Grafton, WI

Sub-Category
Home Entertainment - Interactive, Motion or Illuminated

Division
Semi-Permanent

Award
Silver

Title
Nintendo Accesory Floor Stand for Musicland

Client
Nintendo of America, Inc.

Entrant
Design Phase, Inc.
Northbrook, IL

Sub-Category
Home Entertainment - Non-Interactive, Non-Motion or Non-Illuminated

Division
Permanent

Award
Silver

Title
Nintendo 64 Mobile - Star Wars X-Wing Fighter

Client
Nintendo of America, Inc.

Entrant
Design Phase, Inc.
Northbrook, IL

Sub-Category
Home Entertainment - Non-Interactive, Non-Motion or Non-Illuminated

Division
Temporary

Entertainment and Computers / 49

AWARD
Silver

TITLE
Panasonic Portable CD Player

CLIENT
Panasonic Consumer Electronics

ENTRANT
Art Guild, Inc.
West Deptford, NJ

SUB-CATEGORY
Movies, Tapes, Records, CDs

DIVISION
Permanent

AWARD
Silver

TITLE
Godzilla Spectacular Rain Display

CLIENT
Sony Pictures

ENTRANT
Drissi Advertising, Inc.
Los Angeles, CA

SUB-CATEGORY
Movies, Tapes, Records, CDs

DIVISION
Semi-Permanent

AWARD
Silver

TITLE
Titanic Standee

CLIENT
Paramount Home Video

ENTRANT
Chesapeake Display
and Packaging, Inc.
Winston-Salem, NC

SUB-CATEGORY
Movies, Tapes, Records, CDs

DIVISION
Temporary

50 / Entertainment and Computers

Award
Silver

Title
A Bug's Life

Client
Walt Disney Motion Pictures - Animation

Entrant
Rapid Displays
Union City, CA

Sub-Category
Movies, Tapes, Records, CDs

Division
Semi-Permanent

Award
Bronze

Title
Disney's Flubber Standee

Client
Buena Vista Home Entertainment

Entrant
Phoenix Display,
A Union Camp Company
West Deptford, NJ

Sub-Category
Movies, Tapes, Records, CDs

Division
Temporary

Award
Bronze

Title
Lifestyle Home Theater Display

Client
Bose Corporation

Entrant
United Displaycraft
Des Plaines, IL

Sub-Category
Home Entertainment -
Interactive, Motion or
Illuminated

Division
Permanent

Entertainment and Computers / 51

AWARD
Bronze

TITLE
"Lady and the Tramp" Standee

CLIENT
Buena Vista Home Video

ENTRANT
Origin Display/Ideal Box & Graphics
Burbank, CA

SUB-CATEGORY
Movies, Tapes, Records, CDs

DIVISION
Temporary

AWARD
Bronze

TITLE
Apple Sherlock Merchandiser

CLIENT
CKS Partners

ENTRANT
Rapid Displays
Union City, CA

SUB-CATEGORY
Computer Software

DIVISION
Semi-Permanent

AWARD
Bronze

TITLE
"The Lion King II – Simba's Pride" Standee

CLIENT
Buena Vista Home Video

ENTRANT
Origin Display/Ideal Box & Graphics
Burbank, CA

SUB-CATEGORY
Movies, Tapes, Records, CDs

DIVISION
Temporary

52 / Entertainment and Computers

AWARD
Bronze

TITLE
Classic CD ROM Spinner
Rack - Electronic Arts

CLIENT
Electronic Arts

ENTRANT
White Plus
El Segundo, CA

SUB-CATEGORY
Computer Software

DIVISION
Permanent

AWARD
Bronze

TITLE
New Release CD Tower

CLIENT
Best Buy Stores

ENTRANT
Thorco Industries, Inc.,
Lamar, MO

SUB-CATEGORY
Movies, Tapes, Records, CDs

DIVISION
Permanent

AWARD
Bronze

TITLE
Guitar & Bass Retail Package & Floor Display

CLIENT
Hoshino, U.S.A.

ENTRANT
McLean Packaging Corporation
Phildelphia, PA

SUB-CATEGORY
Home Entertainment - Non-Interactive,
Non-Motion or Non-Illuminated

DIVISION
Semi-Permanent

AWARD
Bronze

TITLE
Pentium II Processor
CompUSA Wall System

CLIENT
Intel Corporation

ENTRANT
Frank Mayer & Associates, Inc.
Grafton, WI

SUB-CATEGORY
Computer Hardware

DIVISION
Permanent

Entertainment and Computers / 53

AWARD
Bronze

TITLE
Pentium II Back to School Retail Campaign

CLIENT
Intel Corporation

ENTRANT
Rapid Displays
Union City, CA

SUB-CATEGORY
Computer Hardware

DIVISION
Semi-Permanent

AWARD
Bronze

TITLE
Pentium II Processor Cartridge Display

CLIENT
Intel Corporation

ENTRANT
Frank Mayer & Associates, Inc.
Grafton, WI

SUB-CATEGORY
Computer Hardware

DIVISION
Permanent

AWARD
Bronze

TITLE
Barney's Big Surprise Floor Display

CLIENT
Lyrick Studios

ENTRANT
Phoenix Display,
A Union Camp Company
West Deptford, NJ

SUB-CATEGORY
Movies, Tapes, Records, CDs

DIVISION
Temporary

AWARD
Bronze

TITLE
Logitech Cordless Keyboard Mouse

CLIENT
Logitech

ENTRANT
Rapid Displays
Union City, CA

SUB-CATEGORY
Computer Hardware

DIVISION
Semi-Permanent

54 / Entertainment and Computers

AWARD
Bronze

TITLE
Ronin Display

CLIENT
MGM/UA Pictures

ENTRANT
Drissi Advertising, Inc.
Los Angeles, CA

SUB-CATEGORY
Movies, Tapes, Records, CDs

DIVISION
Semi-Permanent

AWARD
Bronze

TITLE
Color Game Boy -
Counter Unit

CLIENT
Nintendo of America, Inc.

ENTRANT
Frank Mayer & Associates, Inc.
Grafton, WI

SUB-CATEGORY
Home Entertainment -
Interactive, Motion or
Illuminated

DIVISION
Permanent

AWARD
Bronze

TITLE
Hot "N" Hits and Sports
All Star Hanging Sign

CLIENT
Nintendo of America, Inc.

ENTRANT
Thomson-Leeds Company, Inc.
New York, NY

SUB-CATEGORY
Home Entertainment -
Non-Interactive, Non-Motion
or Non-Illuminated

DIVISION
Semi-Permanent

Entertainment and Computers / 55

AWARD
Bronze

TITLE
Rugrats Display

CLIENT
Paramount Pictures

ENTRANT
Drissi Advertising, Inc.
Los Angeles, CA

SUB-CATEGORY
Movies, Tapes, Records, CDs

DIVISION
Semi-Permanent

AWARD
Bronze

TITLE
Titanic 48-Pc. Prepack Merchandiser

CLIENT
Paramount Home Video

ENTRANT
Chesapeake Display and Packaging, Inc.
Winston-Salem, NC

SUB-CATEGORY
Movies, Tapes, Records, CDs

DIVISION
Temporary

AWARD
Bronze

TITLE
Philips CD-R Display

CLIENT
Philips Consumer Electronics

ENTRANT
Everbrite, Inc.
Greenfield, WI

SUB-CATEGORY
Home Entertainment - Non-Interactive, Non-Motion or Non-Illuminated

DIVISION
Permanent

56 / Entertainment and Computers

AWARD
Bronze

TITLE
Borrowers Display

CLIENT
Polygram Entertainment

ENTRANT
Drissi Advertising, Inc.
Los Angeles, CA

SUB-CATEGORY
Movies, Tapes, Records, CDs

DIVISION
Semi-Permanent

AWARD
Bronze

TITLE
SKY TV Display Kiosk

CLIENT
Sky Latin America L.L.C.

ENTRANT
Chicago Display Marketing
Melrose Park, IL

SUB-CATEGORY
Home Entertainment -
Non-Interactive, Non-Motion
or Non-Illuminated

DIVISION
Permanent

AWARD
Bronze

TITLE
Sony 3-Sided Display

CLIENT
Sony Electronics, Inc.

ENTRANT
United Displaycraft
Des Plaines, IL

SUB-CATEGORY
Home Entertainment -
Non-Interactive, Non-Motion
or Non-Illuminated

DIVISION
Permanent

Entertainment and Computers / 57

AWARD
Bronze

TITLE
Sony Gingerbread Prepack

CLIENT
Sony Music Distribution

ENTRANT
Phoenix Display,
A Union Camp Company
West Deptford, NJ

SUB-CATEGORY
Movies, Tapes, Records, CDs

DIVISION
Temporary

AWARD
Bronze

TITLE
Golden Books Christmas Prepack

CLIENT
Sony Music Distribution

ENTRANT
Phoenix Display,
A Union Camp Company
West Deptford, NJ

SUB-CATEGORY
Movies, Tapes, Records, CDs

DIVISION
Temporary

AWARD
Bronze

TITLE
Ages of Myst Tower Display

CLIENT
The Learning Company

ENTRANT
One Source Ind., LLC
Laguna Hills, CA

SUB-CATEGORY
Computer Software

DIVISION
Temporary

58 / Entertainment and Computers

AWARD
Bronze

TITLE
Schoolhouse Pallet Display

CLIENT
The Learning Company, Inc.

ENTRANT
Goldring Display Group, Inc.
Paramus, NJ

SUB-CATEGORY
Computer Software

DIVISION
Semi-Permanent

AWARD
Bronze

TITLE
Sony Xplod Floor Stand

CLIENT
UPSHOT

ENTRANT
Rapid Displays
Chicago, IL

SUB-CATEGORY
Home Entertainment - Non-Interactive, Non-Motion or Non-Illuminated

DIVISION
Semi-Permanent

AWARD
Bronze

TITLE
Go for the Gear Header

CLIENT
Thomson Consumer Electronics

ENTRANT
Great Northern Corporation
Racine, WI

SUB-CATEGORY
Home Entertainment - Non-Interactive, Non-Motion or Non-Illuminated

DIVISION
Temporary

Entertainment and Computers / 59

Award
Bronze

Title
Valley Media DVD Display

Client
Valley Media

Entrant
Triangle Display Group
Philadelphia, PA

Sub-Category
Movies, Tapes, Records, CDs

Division
Permanent

Award
Bronze

Title
DVD Home Video Display

Client
Warner Home Video

Entrant
Thomson-Leeds Company, Inc.
New York, NY

Sub-Category
Movies, Tapes, Records, CDs

Division
Permanent

Award
Bronze

Title
"Simply Grand" Key Board Display

Client
Yamaha Corporation of America

Entrant
Cornerstone Display Group, Inc.
San Fernando, CA

Sub-Category
Home Entertainment - Interactive, Motion or Illuminated

Division
Permanent

60 / Fragrances

AWARD
Gold

TITLE
Fragrance Plug-Ins

CLIENT
Coty, Inc.

ENTRANT
Advertising Display Company
Lyndhurst, NJ

SUB-CATEGORY
Men's and Women's Colognes,
Fragrances, Eaux de Toilette

DIVISION
Temporary

AWARD
Gold

TITLE
Estée Lauder Dazzling In-
Case Prop

CLIENT
Estée Lauder, Inc.

ENTRANT
Consumer Promotions
International
Mount Vernon, NY

SUB-CATEGORY
Women's Perfumes

DIVISION
Semi-Permanent

AWARD
Gold

TITLE
Stetson Country Launch

CLIENT
Coty, Inc.

ENTRANT
Trans World Marketing
East Rutherford, NJ

SUB-CATEGORY
Men's and Women's Colognes,
Fragrances, Eaux de Toilette

DIVISION
Temporary

Fragrances / 61

AWARD
Gold

TITLE
"Nicole" Fragrance Tester —
Nicole Miller

CLIENT
Riviera Concepts, Inc.

ENTRANT
IDMD Manufacturing, Inc.
Toronto, Ontario, Canada

SUB-CATEGORY
Women's Perfumes

DIVISION
Permanent

AWARD
Silver

TITLE
Coty Aspen Sensation Launch

CLIENT
Coty, Inc.

ENTRANT
Display Producers, Inc.
Bronx, NY

SUB-CATEGORY
Men's and Women's Colognes,
Fragrances, Eaux de Toilette

DIVISION
Temporary

AWARD
Silver

TITLE
Coty April Fields
Cologne Introduction

CLIENT
Coty, Inc.

ENTRANT
Mechtronics Corporation
Stamford, CT

SUB-CATEGORY
Women's Perfumes

DIVISION
Semi-Permanent

62 / Fragrances

AWARD
Silver

TITLE
Estée Lauder Dazzling Counter Unit

CLIENT
Estée Lauder, Inc.

ENTRANT
Consumer Promotions International
Mount Vernon, NY

SUB-CATEGORY
Women's Perfumes

DIVISION
Permanent

AWARD
Silver

TITLE
Tommy / Tommy Girl Master Tester

CLIENT
Estée Lauder, Inc.

ENTRANT
Trans World Marketing
East Rutherford, NJ

SUB-CATEGORY
Men's and Women's Colognes,
Fragrances, Eaux de Toilette

DIVISION
Permanent

AWARD
Bronze

TITLE
Contradiction For
Men Display Program

CLIENT
Calvin Klein

ENTRANT
Consumer Promotions
International
Mount Vernon, NY

SUB-CATEGORY
Men's and Women's
Colognes, Fragrances,
Eaux de Toilette

DIVISION
Semi-Permanent

AWARD
Bronze

TITLE
Chanel for Men
Fragrance Fountains

CLIENT
Chanel, Ltd.

ENTRANT
Diam International
Leicester, England

SUB-CATEGORY
Men's and Women's
Colognes, Fragrances,
Eaux de Toilette

DIVISION
Semi-Permanent

Fragrances / 63

AWARD
Bronze

TITLE
Lancôme "Climate" Fragrance Tester

CLIENT
Cosmair, Inc.

ENTRANT
P.O.P. Displays, International
Woodside, NY

SUB-CATEGORY
Women's Perfumes

DIVISION
Permanent

AWARD
Bronze

TITLE
Lancôme Oui Tester

CLIENT
Cosmair, Inc.

ENTRANT
P.O.P. Displays, International
Woodside, NY

SUB-CATEGORY
Women's Perfumes

DIVISION
Temporary

AWARD
Bronze

TITLE
Healing Garden Floor Display

CLIENT
Coty Canada

ENTRANT
Point 1 Displays, Inc.
Montreal, Quebec, Canada

SUB-CATEGORY
Men's and Women's Colognes, Fragrances, Eaux de Toilette

DIVISION
Temporary

AWARD
Bronze

TITLE
The Elizabeth Arden Splendor Counter Display

CLIENT
Elizabeth Arden

ENTRANT
Consumer Promotions International
Mount Vernon, NY

SUB-CATEGORY
Women's Perfumes

DIVISION
Permanent

64 / Fragrances

AWARD
Bronze

TITLE
Elizabeth Arden Cerruti Image Display Units

CLIENT
Elizabeth Arden

ENTRANT
Consumer Promotions International
Mount Vernon, NY

SUB-CATEGORY
Men's and Women's Colognes, Fragrances, Eaux de Toilette

AWARD
Bronze

TITLE
Estée Lauder Dazzling Vitrine Display

CLIENT
Estée Lauder, Inc.

ENTRANT
Consumer Promotions International
Mount Vernon, NY

SUB-CATEGORY
Women's Perfumes

DIVISION
Permanent

AWARD
Bronze

TITLE
Aramis Tester Display

CLIENT
The Estée Lauder Companies

ENTRANT
The Royal Promotion Group
New York, NY

SUB-CATEGORY
Men's and Women's Colognes, Fragrances, Eaux de Toilette

DIVISION
Permanent

Grocery and General Merchandise Products / 65

Award
Gold

Title
Five Brother's 10 Case Rack

Client
Lipton, Inc.

Entrant
Smurfit-Stone Display Group
Carol Stream, IL

Sub-Category
Containerized and Processed Foods

Division
Temporary

Award
Gold

Title
20 Case SPAM® Movable Display

Client
Hormel Foods Corporation

Entrant
Smyth Companies - Display Division
St. Paul, MN

Sub-Category
Containerized and Processed Foods

Division
Temporary

Award
Gold

Title
Calgon Home Merchandising System - Coty Inc.

Client
Coty, Inc.

Entrant
IDMD Manufacturing, Inc.
Toronto, ON, Canada

Sub-Category
Paper Goods and Soap

Division
Permanent

66 / Grocery and General Merchandise Products

Award
Gold

Title
Bagel Cart - 4'

Client
Maple Leaf Bakery

Entrant
CDA South Inc.
Duluth, GA

Sub-Category
Frozen, Fresh and Refrigerated Foods

Division
Permanent

Award
Gold

Title
Planters Large Baking Display

Client
Nabisco USFG Merchandising Department

Entrant
Smurfit-Stone Display Group
Sandston, VA

Sub-Category
Frozen, Fresh and Refrigerated Foods

Division
Temporary

Award
Silver

Title
Lipton New Pizza Quick

Client
Lipton, Inc.

Entrant
Smurfit-Stone Display Group
Sandston, VA

Sub-Category
Frozen, Fresh and Refrigerated Foods

Division
Temporary

Grocery and General Merchandise Products / 67

AWARD
Silver

TITLE
Shop Around Bakery Table

CLIENT
Otis Spunkmeyer

ENTRANT
Conocraft
McAfee, NJ

SUB-CATEGORY
Frozen, Fresh and Refrigerated Foods

DIVISION
Permanent

AWARD
Silver

TITLE
Blue's Clues Knockdown Display

CLIENT
Mott's USA

ENTRANT
Advertising Display Company
Lyndhurst, NJ

SUB-CATEGORY
Containerized and Processed Foods

DIVISION
Semi-Permanent

AWARD
Silver

TITLE
Primo - Love Of Italian Food Merchandiser

CLIENT
Nabisco Ltd.

ENTRANT
CDA South, Inc.
Duluth, GA

SUB-CATEGORY
Containerized and Processed Foods

DIVISION
Permanent

68 / Grocery and General Merchandise Products

AWARD
Silver

TITLE
Wagwells

CLIENT
Star-Kist Foods, Inc.
Heinz Pet Products

ENTRANT
Longview Fibre
Display Group
Milwaukee, WI

SUB-CATEGORY
Pet Food and
Accessories

DIVISION
Temporary

AWARD
Silver

TITLE
Asparagus Stacker

CLIENT
The Pillsbury Company

ENTRANT
Great Northern Corporation
Racine, WI

SUB-CATEGORY
Containerized and
Processed Foods

DIVISION
Temporary

AWARD
Bronze

TITLE
Eukanuba "99"
Calendar Promotion

CLIENT
IAMS

ENTRANT
Smurfit-Stone Display Group
Carol Stream, IL

SUB-CATEGORY
Pet Food and Accessories

DIVISION
Temporary

AWARD
Bronze

TITLE
Hillshire Farm &
Kahns Floorstand

CLIENT
Hillshire Farms & Kahns

ENTRANT
Chesapeake Display and
Packaging, Inc.
Winston-Salem, NC

SUB-CATEGORY
Frozen, Fresh and
Refrigerated Foods

DIVISION
Temporary

Grocery and General Merchandise Products / 69

AWARD
Bronze

TITLE
McCormick Taco/Fajita Tri-Pack

CLIENT
McCormick & Company

ENTRANT
Smurfit-Stone Display Group
Carol Stream, IL

SUB-CATEGORY
Containerized and Processed Foods

DIVISION
Temporary

AWARD
Bronze

TITLE
Lipton Side Dish Display

CLIENT
Lipton, Inc.

ENTRANT
MZM S.A. de S.V.
Mexico City, Mexico

SUB-CATEGORY
Containerized and Processed Foods

DIVISION
Permanent

AWARD
Bronze

TITLE
J.E.M. Shelf Management System

CLIENT
Kraft Foods, Inc.

ENTRANT
Thomson-Leeds Company, Inc.
New York, NY

SUB-CATEGORY
Containerized and Processed Foods

DIVISION
Permanent

AWARD
Bronze

TITLE
McCormick DSM16

CLIENT
McCormick & Company

ENTRANT
Smurfit-Stone Display Group
Carol Stream, IL

SUB-CATEGORY
Containerized and Processed Foods

DIVISION
Temporary

70 / Grocery and General Merchandise Products

AWARD
Bronze

TITLE
Perimeter Modular Display Rack

CLIENT
Otis Spunkmeyer

ENTRANT
**Conocraft
McAfee, NJ**

SUB-CATEGORY
Frozen, Fresh and Refrigerated Foods

DIVISION
Permanent

AWARD
Bronze

TITLE
Fit Influencer Presentation Kit

CLIENT
Procter & Gamble Co.

ENTRANT
**Chesapeake Display and Packaging, Inc.
Winston-Salem, NC**

SUB-CATEGORY
Frozen, Fresh and Refrigerated Foods

DIVISION
Temporary

AWARD
Bronze

TITLE
Soft Powder Display

CLIENT
Reckitt & Colman

ENTRANT
**Inland Consumer Packaging and Displays
Indianapolis, IN**

SUB-CATEGORY
Paper Goods and Soap

DIVISION
Temporary

Grocery and General Merchandise Products / 71

AWARD
Bronze

TITLE
Holiday Snausage

CLIENT
Star-Kist Foods, Inc. Heinz Pet Products

ENTRANT
Longview Fibre Display Group
Milwaukee, WI

SUB-CATEGORY
Pet Food and Accessories

DIVISION
Temporary

AWARD
Bronze

TITLE
French's Mustard Display

CLIENT
Reckitt & Colman

ENTRANT
Smurfit-Stone Display Group
Carol Stream, IL

SUB-CATEGORY
Containerized and Processed Foods

DIVISION
Temporary

AWARD
Bronze

TITLE
All-Purpose/Heavy Duty Chore Boy

CLIENT
Reckitt & Colman

ENTRANT
Inland Consumer Packaging
and Displays
Indianapolis, IN

SUB-CATEGORY
Paper Goods and Soap

DIVISION
Temporary

72 / Hair and Skin Care

AWARD
Gold

TITLE
Candy Kisses 24ct. Suitcase Counter Display

CLIENT
Beautycology, Inc.

ENTRANT
Triangle Display Group
Philadelphia, PA

SUB-CATEGORY
Skin Care Products

DIVISION
Semi-Permanent

AWARD
Gold

TITLE
Satin Care And Sensor For Women

CLIENT
Gillette Canada

ENTRANT
Techno P.O.S., Inc.
Anjou, Quebec, Canada

SUB-CATEGORY
Skin Care Products

DIVISION
Temporary

AWARD
Gold

TITLE
California Tan Best Seller Counter Display

CLIENT
California Suncare

ENTRANT
Cormark
Rosemont, IL

SUB-CATEGORY
Suntan Products, Lotions, Moisturizers, and Creams

DIVISION
Permanent

Hair and Skin Care / 73

AWARD
Gold

TITLE
Point Of Purchase Tower of Power (POP TOP)

CLIENT
The Gillette Company NA

ENTRANT
Abstrategy Design & Manufacturing, Inc.
Matawan, NJ

SUB-CATEGORY
Brushes, Hairdryers, Razors, and Combs

DIVISION
Permanent

AWARD
Gold

TITLE
Coppertone MVC 192 Pc. Pallet Display

CLIENT
Schering-Plough

ENTRANT
Advertising Display Company
Lyndhurst, NJ

SUB-CATEGORY
Suntan Products, Lotions, Moisturizers, and Creams

DIVISION

AWARD
Silver

TITLE
California Tan Touch of Bali Counter Display

CLIENT
California Suncare

ENTRANT
Cormark
Rosemont, IL

SUB-CATEGORY
Suntan Products, Lotions, Moisturizers, and Creams

DIVISION
Temporary

74 / Hair and Skin Care

AWARD
Silver

TITLE
Biosomme Merchandisers

CLIENT
Dermotological Sciences Inc.

ENTRANT
P.O.P. Displays, International
Woodside, NY

SUB-CATEGORY
Skin Care Products

DIVISION
Temporary

AWARD
Silver

TITLE
Prescriptives Fast Acting

CLIENT
Estée Lauder, Inc.

ENTRANT
P.O.P. Displays, International
Woodside, NY

SUB-CATEGORY
Skin Care Products

DIVISION
Permanent

AWARD
Silver

TITLE
Bathtime Buddie Toy Story PW/FS

CLIENT
Johnson & Johnson Consumer Products Company

ENTRANT
Smurfit-Stone Display Group
Carol Stream, IL

SUB-CATEGORY
Hair Cleansing Treatments

DIVISION
Temporary

AWARD
Silver

TITLE
Elnett FloorstandingMerchandiser

CLIENT
L'Oréal

ENTRANT
Smurfit-Stone Display Group/Cundell Corrugate
Chelmsford, Essex, England

SUB-CATEGORY
Hair Styling and Coloring Products

DIVISION
Temporary

Hair and Skin Care / 75

AWARD
Silver

TITLE
Schick Dangler

CLIENT
Schick Shaving Products Group

ENTRANT
Thomson-Leeds Company, Inc.
New York, NY

SUB-CATEGORY
Brushes, Hairdryers, Razors, and Combs

DIVISION
Semi-Permanent

AWARD
Silver

TITLE
Tony & Tina Hair Mascara Display

CLIENT
Tony & Tina

ENTRANT
The Royal Promotion Group
New York, NY

SUB-CATEGORY
Hair Styling and Coloring Products

DIVISION
Permanent

AWARD
Silver

TITLE
Thermasilk Pre-Loaded Floor Display

CLIENT
Lever Pond's Canada

ENTRANT
Techno P.O.S., Inc.
Anjou, Quebec, Canada

SUB-CATEGORY
Hair Cleansing Treatments

DIVISION
Temporary

AWARD
Silver

TITLE
Sea & Ski Floorstand

CLIENT
Sea & Ski

ENTRANT
The Royal Promotion Group
New York, NY

SUB-CATEGORY
Suntan Products, Lotions, Moisturizers, and Creams

DIVISION
Permanent

76 / Hair and Skin Care

AWARD
Silver

TITLE
Vaseline Intensive Care
Re-Invention Program

CLIENT
Unilever Health Care Products -
U.S.A.

ENTRANT
Mechtronics Corporation
Stamford, CT

SUB-CATEGORY
Suntan Products, Lotions,
Moisturizers, and Creams

DIVISION
Temporary

AWARD
Silver

TITLE
Chap Stick Replica Display

CLIENT
Whitehall-Robins

ENTRANT
Henschel-Steinau, Inc.
Englewood, NJ

SUB-CATEGORY
Skin Care Products

DIVISION
Semi-Permanent

AWARD
Bronze

TITLE
Jergens Face Care Counter Unit

CLIENT
Andrew Jergens

ENTRANT
Phoenix Display,
A Union Camp Company
West Deptford, NJ

SUB-CATEGORY
Skin Care Products

DIVISION
Temporary

Hair and Skin Care / 77

AWARD
Bronze

TITLE
L'Oréal Kids Floor Display

CLIENT
L'Oréal Canada

ENTRANT
Point 1 Displays, Inc.
Montreal, Quebec, Canada

SUB-CATEGORY
Hair Cleansing Treatments

DIVISION
Temporary

AWARD
Bronze

TITLE
Biore Concept '99 Presence Program

CLIENT
Andrew Jergens, Div. Of KAO

ENTRANT
Phoenix Display,
A Union Camp Company
West Deptford, NJ

SUB-CATEGORY
Skin Care Products

DIVISION
Temporary

AWARD
Bronze

TITLE
Lancôme Winter Get Away

CLIENT
Cosmair, Inc.

ENTRANT
P.O.P. Displays, International
Woodside, NY

SUB-CATEGORY
Suntan Products, Lotions,
Moisturizers, and Creams

DIVISION
Semi-Permanent

78 / Hair and Skin Care

AWARD
Bronze

TITLE
Future E Floor Display

CLIENT
L'Oréal Canada

ENTRANT
Point 1 Displays, Inc.
Montreal, Quebec, Canada

SUB-CATEGORY
Skin Care Products

DIVISION
Temporary

AWARD
Bronze

TITLE
L'Oréal Feria Launch Display Program

CLIENT
L'Oréal Retail Division

ENTRANT
Markson Rosenthal & Company
Englewood Cliffs, NJ

SUB-CATEGORY
Hair Styling and Coloring Products

DIVISION
Temporary

AWARD
Bronze

TITLE
L'Oréal Plenitude FUTUR·e 3rd Wave

CLIENT
L'Oréal Retail Division

ENTRANT
Ultimate Display Industries
Jamaica, NY

SUB-CATEGORY
Suntan Products, Lotions, Moisturizers, and Creams

DIVISION
Semi-Permanent

Hair and Skin Care / 79

Award
Bronze

Title
Banana Boat Series of Suncare Displays

Client
Playtex Products, Inc.

Entrant
Henschel-Steinau, Inc.
Englewood, NJ

Sub-Category
Suntan Products, Lotions, Moisturizers, and Creams

Division
Permanent

Award
Bronze

Title
Bath and Body Display

Client
Parfums de Couer, Ltd

Entrant
Melrose Displays, Inc
Passaic, NJ

Sub-Category
Skin Care Products

Division
Permanent

Award
Bronze

Title
Power Tan Raindrops Counter Display

Client
Power Tan Corporation

Entrant
Phoenix Display,
A Union Camp Company
West Deptford, NJ

Sub-Category
Suntan Products, Lotions, Moisturizers, and Creams

Division
Temporary

80 / Hair and Skin Care

AWARD
Bronze

TITLE
Super Lustrous Refrigerator

CLIENT
Revlon, Inc.

ENTRANT
Advertising Display Company
Lyndhurst, NJ

SUB-CATEGORY
Hair Styling and Coloring Products

DIVISION
Temporary

AWARD
Bronze

TITLE
Mach 3 Launch Temporary Displays

CLIENT
The Gillette Company

ENTRANT
Chesapeake Display and Packaging, Inc.
Winston-Salem, NC

SUB-CATEGORY
Brushes, Hairdryers, Razors, and Combs

DIVISION
Temporary

AWARD
Bronze

TITLE
MACH3 Space Show

CLIENT
The Gillette Company NA

ENTRANT
Abstrategy Design & Manufacturing, Inc.
Matawan, NJ

SUB-CATEGORY
Brushes, Hairdryers, Razors, and Combs

DIVISION
Semi-Permanent

AWARD
Bronze

TITLE
Mach 3 Launch Semi-Permanent Displays

CLIENT
The Gillette Company

ENTRANT
Chesapeake Display and Packaging, Inc.
Winston-Salem, NC

SUB-CATEGORY
Brushes, Hairdryers, Razors, and Combs

DIVISION
Semi-Permanent

Hair and Skin Care / 81

AWARD
Bronze

TITLE
Unilever Hairstyle of the Month for CVS

CLIENT
Unilever Home and Personal Care USA

ENTRANT
Phoenix Display, A Union Camp Company
West Deptford, NJ

SUB-CATEGORY
Hair Cleansing Treatments

DIVISION
Temporary

AWARD
Bronze

TITLE
Vichy Capital Soleil Floor Display

CLIENT
Vichy Laboratories Canada

ENTRANT
Techno P.O.S., Inc.
Anjou, Quebec, Canada

SUB-CATEGORY
Suntan Products, Lotions, Moisturizers, and Creams

DIVISION
Temporary

AWARD
Bronze

TITLE
Chap Stick Protect 'em Economy Bin

CLIENT
Whitehall-Robins

ENTRANT
Henschel-Steinau, Inc.
Englewood, NJ

SUB-CATEGORY
Skin Care Products

DIVISION
Semi-Permanent

82 / Health Care

Award
Gold

Title
Ensure Fruitango Floor Display

Client
Abbott Laboratories Canada Inc.

Entrant
Point 1 Displays, Inc.
Montreal, Quebec, Canada

Sub-Category
First Aid and Pharmaceuticals

Division
Temporary

Award
Gold

Title
Cross-Action Power Wing / Floor Display

Client
Oral-B Laboratories

Entrant
Henschel-Steinau, Inc.
Englewood, NJ

Sub-Category
Dentifrices, Mouthwash and Oral Care Implements

Division
Temporary

Award
Gold

Title
Braun Oral-B 3D Plaque Remover Display

Client
Braun

Entrant
Mechtronics Corporation
Stamford, CT

Sub-Category
Dentifrices, Mouthwash and Oral Care Implements

Division
Permanent

Health Care / 83

AWARD
Gold

TITLE
Dial Antibacterial Hand
Sanitizer F/D-P/W

CLIENT
The Dial Corp.

ENTRANT
Henschel-Steinau, Inc.
Englewood, NJ

SUB-CATEGORY
Personal Hygiene, Diapers
and Baby Care Items

DIVISION
Temporary

AWARD
Silver

TITLE
Sinutab Pre-Pack

CLIENT
Accumark Promotions For
Warner-Lambert Canada

ENTRANT
Techno P.O.S., Inc.
Anjou, Quebec, Canada

SUB-CATEGORY
First Aid and Pharmaceuticals

DIVISION
Temporary

AWARD
Silver

TITLE
Colgate Grip 'ems
Toothbrush Floorstand

CLIENT
Colgate-Palmolive Company

ENTRANT
The Display Connection, Inc.
Moonachie, NJ

SUB-CATEGORY
Dentifrices, Mouthwash and
Oral Care Implements

DIVISION
Temporary

84 / Health Care

AWARD
Silver

TITLE
Degree-Body Heat Activated Deodorant

CLIENT
Helene Curtis Division of Unilever

ENTRANT
Pride Container/Display Graphics LLC
Chicago, IL

SUB-CATEGORY
Personal Hygiene, Diapers and
Baby Care Items

DIVISION
Temporary

AWARD
Silver

TITLE
Dial Antibacterial Hand
Sanitizer Tester

CLIENT
The Dial Corp.

ENTRANT
Henschel-Steinau, Inc.
Englewood, NJ

SUB-CATEGORY
Personal Hygiene, Diapers
and Baby Care Items

DIVISION
Permanent

AWARD
Silver

TITLE
Pepcid AC Chewable Floor
Display

CLIENT
Johnson & Johnson - Merck
Consumer Pharm. Co.

ENTRANT
Phoenix Display, A Union
Camp Company
West Deptford, NJ

SUB-CATEGORY
First Aid and Pharmaceuticals

DIVISION
Temporary

Health Care / 85

AWARD
Bronze

TITLE
Oral Care Category Merchandiser

CLIENT
Braun Canada Ltd.

ENTRANT
Gorrie Marketing
Mississuaga, Ontario, Canada

SUB-CATEGORY
Dentifrices, Mouthwash and
Oral Care Implements

DIVISION
Permanent

AWARD
Silver

TITLE
Tru-Fit Stardox
Island Display

CLIENT
Tru-Fit

ENTRANT
Cormark
Rosemont, IL

SUB-CATEGORY
First Aid and
Pharmaceuticals

DIVISION
Permanent

AWARD
Bronze

TITLE
Simulac Advance

CLIENT
Abbott Laboratories Canada, Inc.

ENTRANT
Point 1 Displays, Inc.
Montreal, Quebec, Canada

SUB-CATEGORY
Personal Hygiene, Diapers and
Baby Care Items

DIVISION
Temporary

AWARD
Bronze

TITLE
Incognito "Combo Display"
Pre-Pack

CLIENT
Fempro Inc. of Cascades

ENTRANT
Techno P.O.S., Inc.
Anjou, Quebec, Canada

SUB-CATEGORY
Personal Hygiene, Diapers
and Baby Care Items

DIVISION
Temporary

86 / Health Care

Award
Bronze

Title
Shower To Shower
48 36 PW/FS

Client
Johnson & Johnson

Entrant
Smurfit-Stone Display Group
Carol Stream, IL

Sub-Category
Personal Hygiene, Diapers and Baby Care Items

Division
Temporary

Award
Bronze

Title
First Aid Kit To Go

Client
Johnson & Johnson

Entrant
Smurfit-Stone Display Group
Carol Stream, IL

Sub-Category
First Aid and Pharmaceuticals

Division
Temporary

Award
Bronze

Title
Children's Tylenol Soft Chews Display

Client
McNeil Consumer Healthcare

Entrant
Phoenix Display,
A Union Camp Company
West Deptford, NJ

Sub-Category
First Aid and Pharmaceuticals

Division
Temporary

Award
Bronze

Title
Aquafresh Kids Display

Client
Rapid de Venezuela

Entrant
Rapid Displays
Chicago, IL

Sub-Category
Dentifrices, Mouthwash and Oral Care Implements

Division
Temporary

Health Care / 87

AWARD
Bronze

TITLE
Afrin 33% More Free Display

CLIENT
Schering Plough Health Care Products

ENTRANT
Phoenix Display,
A Union Camp Company
West Deptford, NJ

SUB-CATEGORY
First Aid and Pharmaceuticals

DIVISION
Temporary

AWARD
Gold

TITLE
Crest Multiclean Family of Displays

CLIENT
Procter & Gamble

ENTRANT
Alliance Display & Packaging,
Winston-Salem, NC

SUB-CATEGORY
Dentifrices, Mouthwash and Oral Care Implements

DIVISION
Temporary

AWARD
Bronze

TITLE
Mentadent Pro Care/
Oral Care Display

CLIENT
Unilever HPC USA

ENTRANT
Advertising Display Company
Lyndhurst, NJ

SUB-CATEGORY
Dentifrices, Mouthwash and
Oral Care Implements

DIVISION
Temporary

88 / Health Care

AWARD
Bronze

TITLE
Walgreen's Cough-Cold/Allergy Center

CLIENT
Whitehall-Robins

ENTRANT
Henschel-Steinau, Inc.
Englewood, NJ

SUB-CATEGORY
First Aid and Pharmaceuticals

DIVISION
Permanent

AWARD
Bronze

TITLE
Eckerd Cough/Cold Center

CLIENT
Whitehall-Robins Healthcare

ENTRANT
Smurfit-Stone Display Group
Sandston, VA

SUB-CATEGORY
First Aid and Pharmaceuticals

DIVISION
Semi-Permanent

AWARD
Bronze

TITLE
Whitehall-Robins Herbal Family

CLIENT
Whitehall-Robins Healthcare

ENTRANT
Smurfit-Stone Display Group
Sandston, VA

SUB-CATEGORY
First Aid and Pharmaceuticals

DIVISION
Temporary

Home and Garden / 89

Award
Gold

Title
Dal-Tile Studio Display

Client
Dal-Tile

Entrant
Miller Multiplex
Fenton, MO

Sub-Category
Home Furnishings and Housewares

Division
Permanent

Award
Gold

Title
Quickie Sponge Mop Bucket

Client
Quickie Manufacturing Company

Entrant
Taurus Packaging and Display Corporation
Cherry Hill, NJ

Sub-Category
Home and Industrial Tools

Division
Temporary

Award
Gold

Title
Swiffer Dissolve Floorstand

Client
Procter & Gamble Co.

Entrant
Chesapeake Display and Packaging, Inc.
Winston-Salem, NC

Sub-Category
Home and Industrial Tools

Division
Temporary

90 / Home and Garden

AWARD
Gold

TITLE
Simplicity Spring POP Kit

CLIENT
Simplicity Manufacturing Company

ENTRANT
Bish Creative Display
Lake Zurich, IL

SUB-CATEGORY
Lawn and Garden Supplies

DIVISION
Semi-Permanent

AWARD
Silver

TITLE
Coronado Paint - Bob Timberlake Display

CLIENT
Coronado Paint Company

ENTRANT
Innovative Marketing Solutions, Inc.
Bensenville, IL

SUB-CATEGORY
Building Supplies

DIVISION
Permanent

AWARD
Gold

TITLE
Tarkett "Status" Flooring Display

CLIENT
Tarkett, Inc.

ENTRANT
PFI Displays, Inc.
Rittman, OH

SUB-CATEGORY
Home Furnishings and Housewares

DIVISION
Permanent

Home and Garden / 91

AWARD
Silver

TITLE
DeWalt Bulk Merchandiser

CLIENT
DeWalt Division -
Black & Decker

ENTRANT
Resources Inc. In Display
Cranford, NJ

SUB-CATEGORY
Home and Industrial Tools

DIVISION
Permanent

AWARD
Silver

TITLE
Bossman Lite Driver 2 "Try Me"
Quarter Pallet

CLIENT
Lowes Companies, Inc.

ENTRANT
Glen Oak Inc. Bossman Products
Mississauga, ON, Canada

SUB-CATEGORY
Home and Industrial Tools

DIVISION
Semi-Permanent

AWARD
Silver

TITLE
J. A. Henckels Open Stock
Display

CLIENT
J.A. Henckels Co.

ENTRANT
The Display Connection, Inc.
Moonachie, NJ

SUB-CATEGORY
Home Furnishings and
Housewares

DIVISION
Permanent

92 / Home and Garden

AWARD
Silver

TITLE
Flat Duck Tape 1/2 Side Kick

CLIENT
Manco, Inc.

ENTRANT
Tenneco Packaging Ashland
Ashland, OH

SUB-CATEGORY
Home and Industrial Tools

DIVISION
Temporary

AWARD
Silver

TITLE
Minwax Mini Pallet

CLIENT
Minwax

ENTRANT
Taurus Packaging and Display
Corporation
Cherry Hill, NJ

SUB-CATEGORY
Building Supplies

DIVISION
Temporary

AWARD
Silver

TITLE
Ralph Lauren Paint Department

CLIENT
Sherwin-Williams

ENTRANT
The Niven Marketing Group
Bensenville, IL

SUB-CATEGORY
Building Supplies

DIVISION
Permanent

Home and Garden / 93

Award
Silver

Title
Wells Lamont Dump Bin Display

Client
Wells Lamont

Entrant
Phoenix Display,
A Union Camp Company
West Deptford, NJ

Sub-Category
Lawn and Garden Supplies

Award
Silver

Title
Teledyne Electronic Faucet Filter Display

Client
Teledyne Water Pik

Entrant
Visual Marketing, Inc.
Chicago, IL

Sub-Category
Appliances (large and small)

Division
Permanent

Award
Bronze

Title
7 Tier Placemate and Coaster Display

Client
Acorn

Entrant
Melrose Displays, Inc.
Passaic, NJ

Sub-Category
Home Furnishings and Housewares

Division
Permanent

Award
Bronze

Title
Crown Trade Expressions 2 Rotating Display

Client
Akzo Nobel

Entrant
Consumer Promotions International
Mount Vernon, NY

Sub-Category
Building Supplies

Division
Permanent

94 / Home and Garden

AWARD
Bronze

TITLE
Freestanding Display

CLIENT
Baldwin Hardware Corporation
Lighting Center

ENTRANT
CDA South Inc.
Duluth, GA

SUB-CATEGORY
Building Supplies

DIVISION
Permanent

AWARD
Bronze

TITLE
Corning Blue Heart Pallet Display

CLIENT
Corning Consumer Products
Company

ENTRANT
Tenneco Packaging - Lancaster, PA
Lancaster, PA

SUB-CATEGORY
Home Furnishings and
Housewares

DIVISION
Temporary

AWARD
Bronze

TITLE
Dick Tracy/Stanley

CLIENT
H. Reitman and Company

ENTRANT
Rapid Displays
Chicago, IL

SUB-CATEGORY
Home and Industrial Tools

DIVISION
Temporary

Home and Garden / 95

AWARD
Bronze

TITLE
Silhouette PowerRise
Demonstrator

CLIENT
Hunter Douglas, Inc.

ENTRANT
Thomson-Leeds Company, Inc.
New York, NY

SUB-CATEGORY
Home Furnishings and Housewares

DIVISION
Permanent

AWARD
Bronze

TITLE
Rock Ripper Floor Display

CLIENT
Johnson Level and Tool

ENTRANT
Great Northern Corporation
Racine, WI

SUB-CATEGORY
Home and Industrial Tools

DIVISION
Temporary

AWARD
Bronze

TITLE
International Classics

CLIENT
Langeveld Bulb Company

ENTRANT
Weber Display & Packaging
Philadelphia, PA

SUB-CATEGORY
Lawn and Garden Supplies

DIVISION
Temporary

96 / Home and Garden

Award
Bronze

Title
Skychairs

Client
Mango Graphics

Entrant
Pride Container and Display Graphics LLC.
Chicago, IL

Sub-Category
Home Furnishings and Housewares

Division
Temporary

Award
Bronze

Title
Icicle Demonstrator

Client
Minami International Corporation

Entrant
Thomson-Leeds Company, Inc.
New York, NY

Sub-Category
Building Supplies

Division
Semi-Permanent

Award
Bronze

Title
Lowe's Kobalt Backlit Header Merch. System

Client
Lowe's Home Improvement Warehouse

Entrant
New Dimensions Research Corporation
Melville, NY

Sub-Category
Home and Industrial Tools

Division
Permanent

Home and Garden / 97

Award
Bronze

Title
Rainbird Irrigation Products Display

Client
Rainbird

Entrant
Santa Cruz Industries
Santa Cruz, CA

Sub-Category
Lawn and Garden Supplies

Division
Permanent

Award
Bronze

Title
Sylvania End Cap Light Bulb Display

Client
Osram Sylvania

Entrant
Frank Mayer & Associates, Inc.
Grafton, WI

Sub-Category
Building Supplies

Division
Permanent

Award
Bronze

Title
Accuset X-Tower Display

Client
Senco Fastening System

Entrant
Whitewater Industries
and AMD Industries
Lawrenceburg, IN

Sub-Category
Home and Industrial Tools

Division
Permanent

98 / Interactive

AWARD
Gold

TITLE
Audi Interactive Kiosk

CLIENT
Audi of America, Inc.

ENTRANT
DCI Marketing
Milwaukee, WI

SUB-CATEGORY
Interactive

DIVISION
Permanent

AWARD
Gold

TITLE
Pontiac-GMC Interactive Product Merchandiser

CLIENT
Pontiac-GMC

ENTRANT
DCI Marketing
Milwaukee, WI

SUB-CATEGORY
Interactive

DIVISION
Permanent

AWARD
Gold

TITLE
Exide Interactive Battery Selector

CLIENT
Exide Corporation

ENTRANT
DCI Marketing
Milwaukee, WI

SUB-CATEGORY
Interactive

DIVISION
Permanent

AWARD
Silver

TITLE
Ken Griffey Jr. Protalk Interactive Floorstand

CLIENT
Telestar Interactive

ENTRANT
Phoenix Display,
A Union Camp Company
West Deptford, NJ

SUB-CATEGORY
Interactive

DIVISION
Temporary

Interactive / 99

AWARD
Silver

TITLE
Boots Cover Girl Interactive

CLIENT
Procter & Gamble Co.

ENTRANT
Diam International
Leicester, England

SUB-CATEGORY
Interactive

DIVISION
Permanent

AWARD
Bronze

TITLE
Pentium II Processor
CompUSA In-Line System

CLIENT
Intel Corporation

ENTRANT
Frank Mayer & Associates, Inc.
Grafton, WI

SUB-CATEGORY
Interactive

DIVISION
Permanent

AWARD
Bronze

TITLE
Color Game Boy Display - Wal-Mart Version

CLIENT
Nintendo of America, Inc.

ENTRANT
Frank Mayer & Associates, Inc.
Grafton, WI

SUB-CATEGORY
Interactive

DIVISION
Permanent

100 / *Personal Products and Accessories*

AWARD
Gold

TITLE
Eastpak Lifestyle Merchandiser

CLIENT
Eastpak Corporation

ENTRANT
Trans World Marketing
East Rutherford, NJ

SUB-CATEGORY
Jewelry

DIVISION
Permanent

AWARD
Gold

TITLE
"Shout" Prepaid Calling Card Display System

CLIENT
MCI/World Com

ENTRANT
Chesapeake Display and Packaging, Inc.
Winston-Salem, NC

SUB-CATEGORY
Telecommunications

DIVISION
Temporary

AWARD
Gold

TITLE
New Balance End-Cap

CLIENT
New Balance

ENTRANT
Thomson-Leeds Company, Inc.
New York, NY

SUB-CATEGORY
Footwear and Shoe Care

DIVISION
Permanent

Personal Products and Accessories / 101

AWARD
Gold

TITLE
Namiki Window Display

CLIENT
Pilot Pen France

ENTRANT
PRISME
Surenes, France

SUB-CATEGORY
Jewelry

DIVISION
Semi-Permanent

AWARD
Silver

TITLE
Kids Floormat and Poster

CLIENT
Skechers USA, Inc.

ENTRANT
Dunn Bros. Commercial Printers
Gardena, CA

SUB-CATEGORY
Footwear and Shoe Care

DIVISION
Semi-Permanent

AWARD
Silver

TITLE
Embroidery Floss Center

CLIENT
DMC Corporation

ENTRANT
ImageWorks Display &
Marketing Group
Winston-Salem, NC

SUB-CATEGORY
Apparel and Sewing Notions

DIVISION
Permanent

102 / *Personal Products and Accessories*

AWARD
Silver

TITLE
Epson Shoot to Print

CLIENT
Epson America

ENTRANT
Trans World Marketing
East Rutherford, NJ

SUB-CATEGORY
Fine Items and Cameras

DIVISION
Permanent

AWARD
Silver

TITLE
No Nonsense Trimega Display

CLIENT
Kayser-Roth Corporation

ENTRANT
Chesapeake Display and Packaging, Inc.
Winston-Salem, NC

SUB-CATEGORY
Apparel and Sewing Notions

DIVISION
Permanent

AWARD
Silver

TITLE
HI-TEC A.R.S. Footwear Display

CLIENT
HI-TEC Sports USA, Inc.

ENTRANT
United Displaycraft
Des Plaines, IL

SUB-CATEGORY
Footwear and Shoe Care

DIVISION
Permanent

Personal Products and Accessories / 103

AWARD
Silver

TITLE
Fidomatic Floor Display

CLIENT
Microcell Solutions
Telecommiunications

ENTRANT
Techno P.O.S., Inc.
Anjou, Quebec, Canada

SUB-CATEGORY
Personal Telecommunications

DIVISION
Temporary

AWARD
Silver

TITLE
NIKE Kids Display

CLIENT
Nike, Inc.

ENTRANT
Markson Rosenthal &
Company
Englewood Cliffs, NJ

SUB-CATEGORY
Footwear and Shoe Care

DIVISION
Semi-Permanent

AWARD
Silver

TITLE
Nike Vision & Timing
Specialty Display Case

CLIENT
Nike, Inc.

ENTRANT
RTC Industries, Inc.
Rolling Meadows, IL

SUB-CATEGORY
Jewelry

DIVISION
Permanent

104 / Personal Products and Accessories

Award
Silver

Title
Omnipoint 6' Kiosk

Client
Omnipoint Communications, Inc.

Entrant
Resources Inc. In Display
Cranford, NJ

Sub-Category
Personal Telecommunications

Division
Permanent

Award
Silver

Title
The Spoon Display Program

Client
Seiko/Pulsar

Entrant
Consumer Promotions
International
Mount Vernon, NY

Sub-Category
Jewelry

Division
Permanent

Award
Silver

Title
Sony DCR-PC1

Client
Sony France

Entrant
PRISME
Suresnes, France

Sub-Category
Fine Items and Cameras

Division
Semi-Permanent

Personal Products and Accessories / 105

AWARD
Silver

TITLE
Sprint Spree Cash Wrap

CLIENT
Sprint

ENTRANT
Gage In-Store Marketing
Minneapolis, MN

SUB-CATEGORY
Telecommunications

DIVISION
Permanent

AWARD
Silver

TITLE
Sprint PCS Dimensional Floor Display

CLIENT
Sprint PCS

ENTRANT
DraftWorldwide
Chicago, IL

SUB-CATEGORY
Telecommunications

DIVISION
Semi-Permanent

AWARD
Silver

TITLE
Nokia 5100 Product Launch

CLIENT
The Integer Group-Dallas

ENTRANT
Instore Solutions
Dallas, TX

SUB-CATEGORY
Personal Telecommunications

DIVISION
Permanent

106 / *Personal Products and Accessories*

AWARD
Silver

TITLE
Monet 2 Introduction System

CLIENT
The Monet Group, Inc.

ENTRANT
P.O.P. Displays, International
Woodside, NY

SUB-CATEGORY
Jewelry

DIVISION
Permanent

AWARD
Silver

TITLE
Harley-Davidson Retail Merchandiser

CLIENT
Wolverine Worldwide, Inc.

ENTRANT
AMD Industries, Inc.
Cicero, IL

SUB-CATEGORY
Footwear and Shoe Care

DIVISION
Permanent

AWARD
Silver

TITLE
Wolverine In-Store Merchandising Environment

CLIENT
Wolverine Worldwide, Inc.

ENTRANT
AMD Industries, Inc.
Cicerol, IL

SUB-CATEGORY
Footwear and Shoe Care

DIVISION
Permanent

Personal Products and Accessories / 107

AWARD
Bronze

TITLE
Casio G-Shock Window Display

CLIENT
Casio

ENTRANT
Consumer Promotions
International
Mount Vernon, NY

SUB-CATEGORY
Jewelry

DIVISION
Permanent

AWARD
Bronze

TITLE
KMart Talking Big Bird

CLIENT
KMart Corporation

ENTRANT
Phoenix Display,
A Union Camp Company
West Deptford, NJ

SUB-CATEGORY
Apparel and Sewing Notions

DIVISION
Permanent

AWARD
Bronze

TITLE
Fender,
The American Standard

CLIENT
Fender Musical Instruments

ENTRANT
Fiberoptic Lighting, Inc.
Grants Pass, OR

SUB-CATEGORY
Fine Items and Cameras

DIVISION
Permanent

108 / *Personal Products and Accessories*

AWARD
Bronze

TITLE
Motorola Startac Display

CLIENT
McCann Communication

ENTRANT
PRISME
Suresnes, France

SUB-CATEGORY
Personal Telecommunications

DIVISION
Permanent

AWARD
Bronze

TITLE
Spirit 2-Way Radio Display

CLIENT
Motorola

ENTRANT
ASA, Inc.
Bensenville, IL

SUB-CATEGORY
Telecommunications

DIVISION
Permanent

AWARD
Bronze

TITLE
Motorola TalkAbout
Counter Display

CLIENT
Motorola

ENTRANT
Marketing Support, Inc.
Chicago, IL

SUB-CATEGORY
Personal Telecommunications

DIVISION
Permanent

Personal Products and Accessories / 109

AWARD
Bronze

TITLE
Nike Footlocker Dedicated Space Program

CLIENT
Nike, Inc.

ENTRANT
JP Marketing Services
Santa Fe Springs, CA

SUB-CATEGORY
Apparel and Sewing Notions

DIVISION
Permanent

AWARD
Bronze

TITLE
Nike T@C Golf Shoe Display

CLIENT
Nike, Inc.

ENTRANT
JP Marketing Services
Santa Fe Springs, CA

SUB-CATEGORY
Footwear and Shoe Care

DIVISION
Permanent

AWARD
Bronze

TITLE
Omnipoint Counter Spinner

CLIENT
Omnipoint Communications, Inc.

ENTRANT
Resources Inc. In Display
Cranford, NJ

SUB-CATEGORY
Personal Telecommunications

DIVISION
Permanent

110 / *Personal Products and Accessories*

AWARD
Bronze

TITLE
Arctic Zone Tower Display

CLIENT
Outer Circle Products, Ltd.

ENTRANT
Smurfit-Stone Display Group
Carol Stream, IL

SUB-CATEGORY
Jewelry

DIVISION
Temporary

AWARD
Bronze

TITLE
Hanes Pallet

CLIENT
Sara Lee

ENTRANT
Arrow Art Finishers, L.L.C.
Bronx, NY

SUB-CATEGORY
Apparel and Sewing Notions

DIVISION
Temporary

AWARD
Bronze

TITLE
Adidas Predator Accelerator

CLIENT
Sandstrom Design

ENTRANT
Rapid Displays
Union City, CA

SUB-CATEGORY
Footwear and Shoe Care

DIVISION
Semi-Permanent

Personal Products and Accessories / 111

AWARD
Bronze

TITLE
Skechers Kid's Promotion Slatwall Display

CLIENT
Skechers USA

ENTRANT
Phoenix Display,
A Union Camp Company
West Deptford, NJ

SUB-CATEGORY
Footwear and Shoe Care

DIVISION
Temporary

AWARD
Bronze

TITLE
Seiko / Pulsar In-Store Banner Program

CLIENT
Seiko Corporation of America

ENTRANT
Abstrategy Design & Manufacturing, Inc.
Matawan, NJ

SUB-CATEGORY
Jewelry

DIVISION
Permanent

AWARD
Bronze

TITLE
SKECHERS USA Inflatable Slatwall Shelf

CLIENT
Skechers USA

ENTRANT
Small Wonder Inflatables
and United Displaycraft
Des Plaines, IL

SUB-CATEGORY
Footwear and Shoe Care

DIVISION
Permanent

112 / *Personal Products and Accessories*

AWARD
Bronze

TITLE
Slights Promotion

CLIENT
Skechers USA, Inc.

ENTRANT
Dunn Bros. Commercial Printers
Gardena, CA

SUB-CATEGORY
Footwear and Shoe Care

DIVISION
Semi-Permanent

AWARD
Bronze

TITLE
ICD Recorders Display–Sony

CLIENT
Sony Electronics, Inc.

ENTRANT
IDMD Manufacturing, Inc.
Toronto, ON, Canada

SUB-CATEGORY
Fine Items and Cameras

DIVISION
Permanent

AWARD
Bronze

TITLE
Sony/Sprint POP Counter Display

CLIENT
Sony PMC of America

ENTRANT
Thomson-Leeds Company, Inc.
New York, NY

SUB-CATEGORY
Personal Telecommunications

DIVISION
Permanent

AWARD
Bronze

TITLE
Sprint Spree Floorstand

CLIENT
Sprint

ENTRANT
Gage In-Store Marketing
Minneapolis, MN

SUB-CATEGORY
Telecommunications

DIVISION
Permanent

Personal Products and Accessories / 113

Award
Bronze

Title
Sprint Movie Tickets

Client
Sprint Corporation

Entrant
**DraftWorldwide
Chicago, IL**

Sub-Category
Personal Telecommunications

Division
Temporary

Award
Bronze

Title
Timberland Pack and Accessories Merchandiser

Client
Timberland Packs and Travel Gear

Entrant
**Trans World Marketing
East Rutherford, NJ**

Sub-Category
Jewelry

Division
Permanent

Award
Bronze

Title
Touchpoint Phone Launch Dimensional Display

Client
Sprint PCS

Entrant
**DraftWorldwide
Chicago, IL**

Sub-Category
Telecommunications

Division
Semi-Permanent

114 / *Personal Products and Accessories*

AWARD
Bronze

TITLE
Tommy Hilfiger Eyewear Glorifer

CLIENT
Tommy Hilfiger Eyewear

ENTRANT
Thomson-Leeds Company, Inc.
New York, NY

SUB-CATEGORY
Jewelry

DIVISION
Permanent

AWARD
Bronze

TITLE
Hanes Pallet Display

CLIENT
Totes

ENTRANT
Buckeye Container
Wooster, OH

SUB-CATEGORY
Apparel and Sewing Notions

DIVISION
Temporary

AWARD
Bronze

TITLE
Van's Kalani Robb Floor Display

CLIENT
Van's, Inc.

ENTRANT
R/P Creative Sales, Inc.
Burbank, CA

SUB-CATEGORY
Footwear and Shoe Care

DIVISION
Permanent

Retailer Showcase / 115

Award
Gold

Title
Target Battery Display System

Client

Entrant
Gage In-Store Marketing
Minneapolis, MN

Sub-Category
Mass Merchandisers

Division
Permanent

Award
Silver

Title
K-mart Video Games System

Client
KMart Corporation

Entrant
RTC Industries, Inc.
Rolling Meadows, IL

Sub-Category
Mass Merchandisers

Division
Permanent

Award
Gold

Title
K-Mart Martha Stewart Crown Molding

Client
KMart Corporation

Entrant
Phoenix Display,
A Union Camp Company
West Deptford, NJ

Sub-Category
Mass Merchandisers

Division
Permanent

116 / Retailer Showcase

AWARD
Silver

TITLE
Radio Shack Compaq Store-Within-A-Store

CLIENT
Radio Shack

ENTRANT
Trans World Marketing
East Rutherford, NJ

SUB-CATEGORY
Other

DIVISION
Permanent

AWARD
Bronze

TITLE
Beautiful Values Dump Bin Floor Display

CLIENT
General Nutrition Corp.

ENTRANT
Henschel-Steinau, Inc.
Englewood, NJ

SUB-CATEGORY
Other

DIVISION
Semi-Permanent

AWARD
Silver

TITLE
Sears Mall Entrance Display

CLIENT
Schwarz Worldwide

ENTRANT
Rapid Displays
Chicago, IL

SUB-CATEGORY
Mass Merchandisers

DIVISION
Temporary

AWARD
Bronze

TITLE
Circuit City Stores' New Sign Package

CLIENT
Circuit City Stores, Inc.

ENTRANT
Phoenix Display,
A Union Camp Company
West Deptford, NJ

SUB-CATEGORY
Other

DIVISION
Permanent

Retailer Showcase / 117

Award
Bronze

Title
Nintendo Wall Merchandiser for Musicland

Client
Nintendo of America, Inc.

Entrant
Design Phase, Inc.
Northbrook, IL

Sub-Category
Mass Merchandisers

Division
Permanent

Award
Bronze

Title
Jewelry Backwall System

Client
Sears Canada

Entrant
CDA South Inc.
Duluth, GA

Sub-Category
Mass Merchandisers

Division
Permanent

Award
Bronze

Title
Walmart DVD Merchandising Showcase

Client
Wal-Mart Stores

Entrant
Thorco Industries, Inc.
Lamar, MO

Sub-Category
Mass Merchandisers

Division
Permanent

118 / Services

Award
Gold

Title
McDonald's Animal Kingdom Kiosk

Client
The Worldwide Company

Entrant
Rapid Displays
Chicago, IL

Sub-Category
Quick Service Food Restaurants

Division
Temporary

Award
Gold

Title
1930s Celebrate The Century Millennium Clock

Client
United States Postal Service

Entrant
DraftWorldwide
Chicago, IL

Sub-Category
Professional Services

Division
Semi-Permanent

Services / 119

AWARD
Silver

TITLE
Taco Bell-Godzilla Kid's Meal Insert 1 and 2

CLIENT
Wunderman Cato Johnson

ENTRANT
Rapid Displays
Chicago, IL

SUB-CATEGORY
Quick Service Food Restaurants

DIVISION
Temporary

AWARD
Silver

TITLE
Statoil Fast-Food Display

CLIENT
Statoil Marketing Norway

ENTRANT
Leo Burnett Foersteledd AS
Oslo, Norway

SUB-CATEGORY
Quick Service Food Restaurants

DIVISION
Permanent

AWARD
Bronze

TITLE
Auntie Anne's Modular Menu Board

CLIENT
Auntie Anne's

ENTRANT
Visual Marketing, Inc.
Chicago, IL

SUB-CATEGORY
Quick Service Food Restaurants

DIVISION
Permanent

120 / Services

AWARD
Bronze

TITLE
K-Bank Info Center

CLIENT
Christiania Bank & Kreditkasse

ENTRANT
Leo Burnett Foersteledd AS
Oslo, Norway

SUB-CATEGORY
Professional Services

DIVISION
Permanent

AWARD
Bronze

TITLE
GMSPO Goodwrench Service Plus

CLIENT
GMSPO

ENTRANT
DCI Marketing
Milwaukee, WI

SUB-CATEGORY
Other Services and Establishments

DIVISION
Permanent

AWARD
Bronze

TITLE
Taco Bell Godzilla Standee–
Phase 1 and 2

CLIENT
Wunderman Cato Johnson

ENTRANT
Rapid Displays
Chicago, IL

SUB-CATEGORY
Quick Service Food Restaurants

DIVISION
Temporary

Snack Products and Soft Drinks / 121

AWARD
Gold

TITLE
Bi-Lo Baby Bull Gravity Feed Floorstand

CLIENT
Bi-Lo Stores, Inc., Subsidiary of Ahold USA

ENTRANT
Taurus Packaging and Display Corporation
Cherry Hill, NJ

SUB-CATEGORY
Snacks, Cookies and Crackers

DIVISION
Semi-Permanent

AWARD
Gold

TITLE
7UP "Hit The Road" Car Display

CLIENT
Dr. Pepper

ENTRANT
Bish Creative Display
Lake Zurich, IL

SUB-CATEGORY
Soft Drinks, Mineral Waters
and Powdered Mixes

DIVISION
Temporary

AWARD
Gold

TITLE
WOW! Shoparound

CLIENT
Frito-Lay, Inc.

ENTRANT
Advertising Display Company
Lyndhurst, NJ

SUB-CATEGORY
Snacks, Cookies and Crackers

DIVISION
Permanent

122 / Snack Products and Soft Drinks

AWARD
Gold

TITLE
Frito-Lay Planet Lunch

CLIENT
Frito-Lay, Inc.

ENTRANT
DCI Marketing
Milwaukee, WI

SUB-CATEGORY
Snacks, Cookies
and Crackers

DIVISION
Permanent

AWARD
Gold

TITLE
Halloween "Sea Witch"
Display

CLIENT
H. E. Butt

ENTRANT
Retail Creative Services,
an Amer. Greet. Co.
Cleveland, OH

SUB-CATEGORY
Candy, Gum and Mints

DIVISION
Temporary

AWARD
Silver

TITLE
Brach's Fresh Candy Shoppe

CLIENT
Brach & Brock Confections

ENTRANT
AMD Industries, Inc.
Cicero, IL

SUB-CATEGORY
Candy, Gum and Mints

DIVISION
Permanent

Snack Products and Soft Drinks / 123

AWARD
Silver

TITLE
Coca-Cola "Pop-Up"
Refrigerated Cooler

CLIENT
Coca-Cola USA

ENTRANT
Merchandising Resources, Inc.
Hollywood, FL

SUB-CATEGORY
Soft Drinks, Mineral Waters
and Powdered Mixes

DIVISION
Permanent

AWARD
Silver

TITLE
Coca-Cola Footpath Interrupter

CLIENT
Coca-Cola Amatil

ENTRANT
EGR Display
Sydney, Australia

SUB-CATEGORY
Soft Drinks, Mineral Waters and
Powdered Mixes

DIVISION
Permanent

AWARD
Silver

TITLE
A & W Halloween Display
Program

CLIENT
Dr. Pepper

ENTRANT
Bish Creative Display
Lake Zurich, IL

SUB-CATEGORY
Soft Drinks, Mineral Waters and
Powdered Mixes

DIVISION
Temporary

AWARD
Silver

TITLE
Planet Lunch

CLIENT
Frito-Lay, Inc.

ENTRANT
Inland Consumer Packaging
and Displays
Indianapolis, IN

SUB-CATEGORY
Snacks, Cookies and Crackers

DIVISION
Semi-Permanent

124 / Snack Products and Soft Drinks

Award
Silver

Title
Fiesta Bowl Triple O'Stacker

Client
Frito-Lay, Inc.

Entrant
Inland Consumer Packaging
and Displays
Indianapolis, IN

Sub-Category
Snacks, Cookies and Crackers

Division
Temporary

Award
Silver

Title
Slushies Semi-Permanent
Floor Display

Client
Kraft Foods, Inc.

Entrant
Henschel-Steinau, Inc.
Englewood, NJ

Sub-Category
Soft Drinks, Mineral Waters
and Powdered Mixes

Division
Semi-Permanent

Award
Silver

Title
NFL Kiss Character Cane Display

Client
Hershey Chocolate USA

Entrant
Triangle Display Group
Philadelphia, PA

Sub-Category
Candy, Gum and Mints

Division
Temporary

Snack Products and Soft Drinks / 125

Award
Silver

Title
Treasures Trial Floorstand

Client
Nestlé Food Company

Entrant
Chesapeake Display
and Packaging, Inc.
Winston-Salem, NC

Sub-Category
Candy, Gum and Mints

Division
Temporary

Award
Silver

Title
Aisle Architecture

Client
Nabisco

Entrant
Conocraft
McAfee, NJ

Sub-Category
Snacks, Cookies
and Crackers

Division
Permanent

Award
Bronze

Title
Coca-Cola Teen Zone

Client
Coca-Cola USA

Entrant
Iowa Rotocast Plastics Inc.
Decorah, IA

Sub-Category
Soft Drinks, Mineral Waters
and Powdered Mixes

Division
Permanent

Award
Silver

Title
Pringles Tower Display
Program

Client
Procter & Gamble Co.

Entrant
Rand Display, Inc.
Teaneck, NJ

Sub-Category
Snacks, Cookies and Crackers

Division
Temporary

126 / Snack Products and Soft Drinks

AWARD
Silver

TITLE
Thirst Machine Jr. Display

CLIENT
The Coca-Cola Company

ENTRANT
The Niven Marketing Group,
Elk Grove Village, IL

SUB-CATEGORY
Soft Drinks, Mineral Water &
Powdered Mixes

DIVISION
Permanent

AWARD
Bronze

TITLE
Frito-Lay Planet Lunch
"Slice" Dress Up Kit

CLIENT
Frito-Lay, Inc.

ENTRANT
DCI Marketing
Milwaukee, WI

SUB-CATEGORY
Snacks, Cookies and
Crackers

DIVISION
Permanent

AWARD
Bronze

TITLE
Wow Triple O'Stacker

CLIENT
Frito-Lay, Inc.

ENTRANT
Inland Consumer Packaging and Displays
Indianapolis, IN

SUB-CATEGORY
Snacks, Cookies and Crackers

DIVISION
Temporary

Snack Products and Soft Drinks / 127

AWARD
Bronze

TITLE
Modular LU Patisserie Hutch

CLIENT
Great Brands of Europe, Inc.

ENTRANT
Conocraft
McAfee, NJ

SUB-CATEGORY
Snacks, Cookies and Crackers

DIVISION
Temporary

AWARD
Bronze

TITLE
Hershey's Godzilla Program

CLIENT
Hershey North America

ENTRANT
Chesapeake Display
and Packaging, Inc.
Winston-Salem, NC

SUB-CATEGORY
Candy, Gum and Mints

DIVISION
Temporary

AWARD
Bronze

TITLE
Fisher Snack'N Serve Nut Bowl
Display

CLIENT
John B. Sanfilippo & Son, Inc.

ENTRANT
Smurfit-Stone Display Group
Carol Stream, IL

SUB-CATEGORY
Snacks, Cookies and Crackers

DIVISION
Temporary

128 / Snack Products and Soft Drinks

Award
Bronze

Title
Jello Frozen Pops Display

Client
Kraft Foods, Inc.

Entrant
Conocraft
McAfee, NJ

Sub-Category
Snacks, Cookies and Crackers

Division
Temporary

Award
Bronze

Title
Lindt Holiday Bulk Display

Client
Lindt & Spruneli

Entrant
Phoenix Display,
A Union Camp Company
West Deptford, NJ

Sub-Category
Candy, Gum and Mints

Division
Temporary

Award
Bronze

Title
Nilla Wooden Permanent Rack

Client
Nabisco Biscuit Company

Entrant
Chicago Display Marketing
Melrose Park, IL

Sub-Category
Snacks, Cookies and Crackers

Division
Permanent

Award
Bronze

Title
CremeSavers Counter Display

Client
Nabisco Ltd.

Entrant
ImageWorks Display & Marketing Group
Winston-Salem, NC

Sub-Category
Candy, Gum and Mints

Division
Semi-Permanent

Snack Products and Soft Drinks / 129

AWARD
Bronze

TITLE
Ocean Spray Serpentine III

CLIENT
Ocean Spray

ENTRANT
Display Technologies
College Point, NY

SUB-CATEGORY
Soft Drinks, Mineral Waters
and Powdered Mixes

DIVISION
Semi-Permanent

AWARD
Bronze

TITLE
Nestlé/Sunmark Bugs Life Pallet Display

CLIENT
Nestlé Food Company

ENTRANT
Chesapeake Display and Packaging, Inc.
Winston-Salem, NC

SUB-CATEGORY
Candy, Gum and Mints

DIVISION
Temporary

AWARD
Bronze

TITLE
Pepperidge Farm Modular
End Cap System

CLIENT
Pepperidge Farm

ENTRANT
Smurfit-Stone Display Group
Sandston, VA

SUB-CATEGORY
Snacks, Cookies and
Crackers

DIVISION
Temporary

130 / Snack Products and Soft Drinks

AWARD
Bronze

TITLE
Street Talker - Pepsi and Mountain Dew

CLIENT
Pepsi-Cola Company

ENTRANT
Markson Rosenthal & Company
Englewood Cliffs, NJ

SUB-CATEGORY
Soft Drinks, Mineral Waters and Powdered Mixes

DIVISION
Permanent

AWARD
Bronze

TITLE
Pepsi One Launch POP Program

CLIENT
Pepsi-Cola Company

ENTRANT
Prestige Display & Packaging
West Chester, OH

SUB-CATEGORY
Soft Drinks, Mineral Waters and Powdered Mixes

DIVISION
Temporary

AWARD
Bronze

TITLE
Sprite Kobe Ceiling Crasher

CLIENT
The Coca Cola Company

ENTRANT
Cadmus Point of Purchase
Atlanta, GA

SUB-CATEGORY
Soft Drinks, Mineral Waters and Powdered Mixes

DIVISION
Semi-Permanent

AWARD
Bronze

TITLE
Halloween Distorted Mirror

CLIENT
Pepsi-Cola Company

ENTRANT
The Display Connection, Inc.
Moonachie, NJ

SUB-CATEGORY
Soft Drinks, Mineral Waters and Powdered Mixes

DIVISION
Temporary

Sports, Toys and Accessories / 131

AWARD
Gold

TITLE
A Bug's Life Floor Display

CLIENT
Applause Inc./Justman Packaging

ENTRANT
Applause, Inc.
Woodland Hills, CA

SUB-CATEGORY
Toys

DIVISION
Temporary

AWARD
Gold

TITLE
DK Children's Encyclopedia Floorstand

CLIENT
D.K. Publishing, Inc.

ENTRANT
Taurus Packaging and Display Corporation
Cherry Hill, NJ

SUB-CATEGORY
Books, Newspapers and Magazines

DIVISION
Semi-Permanent

AWARD
Gold

TITLE
Veggie Tales Environment

CLIENT
Big Idea Productions

ENTRANT
Trans World Marketing
East Rutherford, NJ

SUB-CATEGORY
Toys

DIVISION
Permanent

132 / Sports, Toys and Accessories

Award
Gold

Title
A Bug's Life Feature Area

Client
Disney Consumer Products and Mattel

Entrant
White Plus
El Segundo, CA

Sub-Category
Toys

Division
Temporary

Award
Gold

Title
Bat, Glove and Bag Display

Client
Worth, Inc.

Entrant
Frank Mayer & Associates, Inc.
Grafton, WI

Sub-Category
Sports Equipment

Division
Permanent

Award
Silver

Title
Storytime Treasures Library

Client
Advance Publishers

Entrant
Conocraft
McAfee, NJ

Sub-Category
Books, Newspapers and Magazines

Division
Semi-Permanent

Sports, Toys and Accessories / 133

AWARD
Silver

TITLE
Duracell Godzilla Battery Display

CLIENT
Duracell U.S.A.

ENTRANT
Phoenix Display,
A Union Camp Company
West Deptford, NJ

SUB-CATEGORY
Film and Batteries

DIVISION
Temporary

AWARD
Silver

TITLE
Master Peace Print Bin

CLIENT
DaySpring Cards

ENTRANT
E and E Display Group
Lawrence, KS

SUB-CATEGORY
Books, Newspapers and Magazines

DIVISION
Permanent

AWARD
Silver

TITLE
Duracell Ultra Floorstand Display

CLIENT
Duracell U.S.A.

ENTRANT
Thomson-Leeds Company, Inc.
New York, NY

SUB-CATEGORY
Film and Batteries

DIVISION
Permanent

AWARD
Silver

TITLE
Golden Books Christmas Event 1998

CLIENT
Golden Books Publishing

ENTRANT
Smurfit-Stone Display Group
Sandston, VA

SUB-CATEGORY
Books, Newspapers and Magazines

DIVISION
Temporary

134 / Sports, Toys and Accessories

AWARD
Silver

TITLE
Louisville Hockey Blade
& Shaft Display

CLIENT
Louisville Hockey

ENTRANT
DCI Marketing
Milwaukee, WI

SUB-CATEGORY
Sports Equipment

DIVISION
Permanent

AWARD
Silver

TITLE
Wine Spectator Best
Of NY Floorstand

CLIENT
M. Shanken
Communications, Inc.

ENTRANT
Taurus Packaging and
Display Corporation
Cherry Hill, NJ

SUB-CATEGORY
Books, Newspapers
and Magazines

DIVISION
Temporary

AWARD
Silver

TITLE
My Interactive Pooh Display

CLIENT
Mattel Toys

ENTRANT
Frank Mayer & Associates, Inc.
Grafton, WI

SUB-CATEGORY
Toys

DIVISION
Permanent

AWARD
Silver

TITLE
Jungle Joe Activity Center

CLIENT
RNR, Inc.

ENTRANT
Kell Specialty Products
Chippewa Falls, WI

SUB-CATEGORY
Toys

DIVISION
Semi-Permanent

Sports, Toys and Accessories / 135

AWARD
Silver

TITLE
Top Flite High Performance Golf Ball Counter

CLIENT
Spalding Sports Worldwide

ENTRANT
Mechtronics Corporation
Stamford, CT

SUB-CATEGORY
Sports Equipment

DIVISION
Permanent

AWARD
Silver

TITLE
Titleist 36DZ Analyzer Floor Display

CLIENT
Titleist/Foot Joy Worldwide

ENTRANT
Triangle Display Group
Philadelphia, PA

SUB-CATEGORY
Sports Equipment

DIVISION
Temporary

AWARD
Bronze

TITLE
Barnes & Noble Dolly Display

CLIENT
Barnes & Noble

ENTRANT
Medallion Associates
New York, NY

SUB-CATEGORY
Books, Newspapers and Magazines

DIVISION
Permanent

136 / Sports, Toys and Accessories

AWARD
Bronze

TITLE
D.K. Learn to Read Mobile

CLIENT
D.K. Publishing, Inc.

ENTRANT
Taurus Packaging and Display Corporation
Cherry Hill, NJ

SUB-CATEGORY
Books, Newspapers and Magazines

DIVISION
Semi-Permanent

AWARD
Bronze

TITLE
Dunlop–Maxfli Iron Display

CLIENT
Dunlop Maxfli Sports Corporation

ENTRANT
DCI Marketing
Milwaukee, WI

SUB-CATEGORY
Sports Equipment

DIVISION
Permanent

AWARD
Bronze

TITLE
Walgreen's Counter Display

CLIENT
Duracell U.S.A.

ENTRANT
Accent Display Corporation
Cranston, RI

SUB-CATEGORY
Film and Batteries

DIVISION
Permanent

Sports, Toys and Accessories / 137

Award
Bronze

Title
PHL6PHTEK01 with 2 Ultra SKU's Counter Unit

Client
Duracell U.S.A.

Entrant
Chesapeake Display and Packaging, Inc.
Winston-Salem, NC

Sub-Category
Film and Batteries

Division
Semi-Permanent

Award
Bronze

Title
Duracell Ultra Counter Unit

Client
Duracell U.S.A.

Entrant
Thomson-Leeds Company, Inc.
New York, NY

Sub-Category
Film and Batteries

Division
Permanent

Award
Bronze

Title
Mark McGwire and Sammy Sosa Collectors' Cases

Client
Equity Marketing, Inc.

Entrant
Tenneco Packaging
South Gate, CA

Sub-Category
Toys

Division
Permanent

Award
Bronze

Title
Hercules Pallet Film Tower

Client
Kodak Canada, Inc.

Entrant
Protagon Display, Inc.
Scarborough, Ontario, Canada

Sub-Category
Film and Batteries

Division
Temporary

138 / Sports, Toys and Accessories

Award
Bronze

Title
Mattel/Titanic Puzzle Pallet

Client
Mattel, Inc.

Entrant
Taurus Packaging
and Display Corporation
Cherry Hill, NJ

Sub-Category
Toys

Division
Temporary

Award
Bronze

Title
Dr. Seuss Flashcard
Floorstand

Client
Random House, Inc.,
Children's Publishing

Entrant
Taurus Packaging and
Display Corporation
Cherry Hill, NJ

Sub-Category
Books, Newspapers
and Magazines

Division
Temporary

Award
Bronze

Title
Zoob Mobile

Client
Primordial, LLC

Entrant
Rapid Displays
Union City, CA

Sub-Category
Toys

Division
Permanent

Award
Bronze

Title
Hot Wheels Cyber Racers
Counter Display

Client
Mattel, Inc.

Entrant
Tenneco Packaging
South Gate, CA

Sub-Category
Toys

Division
Semi-Permanent

Sports, Toys and Accessories / 139

AWARD
Bronze

TITLE
Shimano Flight Deck Counter Display

CLIENT
Shimano American Corporation

ENTRANT
Cormark
Rosemont, IL

SUB-CATEGORY
Sports Equipment

DIVISION
Permanent

AWARD
Bronze

TITLE
"Easy Store" Basketball Display

CLIENT
The Little Tikes Company

ENTRANT
Retail Creative Services, an American Greetings Company
Cleveland, OH

SUB-CATEGORY
Toys

DIVISION
Permanent

AWARD
Bronze

TITLE
View Swim Goggle and Lens Display

CLIENT
Tabata USA, Inc.

ENTRANT
R/P Creative Sales, Inc.
Burbank, CA

SUB-CATEGORY
Sports Equipment

DIVISION
Permanent

140 / Sports, Toys and Accessories

AWARD
Bronze

TITLE
Fat Shaft Floor Display

CLIENT
Wilson Sporting Goods

ENTRANT
Great Northern Corporation
Racine, WI

SUB-CATEGORY
Sports Equipment

DIVISION
Temporary

AWARD
Bronze

TITLE
1999 Olds Farmer's Almanac 36/20 Floorstand

CLIENT
Yankee Publishing Co., Inc.

ENTRANT
Triangle Display Group
Philadelphia, PA

SUB-CATEGORY
Books, Newspapers and Magazines

DIVISION
Semi-Permanent

AWARD
Bronze

TITLE
Fat Shaft Iron Stand Up

CLIENT
Wilson Sporting Goods

ENTRANT
Great Northern Corporation
Racine, WI

SUB-CATEGORY
Sports Equipment

DIVISION
Semi-Permanent

Stationery, Office Supplies and Seasonal Goods / 141

AWARD
Gold

TITLE
BIC Tax-Time Pallet Display For Staples

CLIENT
BIC Corporation

ENTRANT
Triangle Display Group
Philadelphia, PA

SUB-CATEGORY
Stationery, Party Goods, Giftwrap, Disposable Writing

DIVISION
Semi-Permanent

AWARD
Gold

TITLE
At-A-Glance/Office Max Modular Merch. System

CLIENT
The AT-A-GLANCE Group

ENTRANT
New Dimensions Research Corporation
Melville, NY

SUB-CATEGORY
Office Equipment and Supplies

DIVISION
Permanent

AWARD
Gold

TITLE
M&M/MARS 1998 Halloween

CLIENT
M&M/MARS

ENTRANT
Smurfit-Stone Display Group
Sandston, VA

SUB-CATEGORY
Stationery, Party Goods, Giftwrap, Disposable Writing

DIVISION
Temporary

142 / Stationery, Office Supplies and Seasonal Goods

Award
Silver

Title
Rugrats Endcap - 3' Display

Client
American Greetings

Entrant
American Greetings, Corp.
Cleveland, OH

Sub-Category
Greeting Cards

Division
Temporary

Award
Silver

Title
Little Inspirations Spinner

Client
DaySpring Cards

Entrant
E and E Display Group
Lawrence, KS

Sub-Category
Greeting Cards

Division
Permanent

Award
Silver

Title
Tape And Mailing Pallet

Client
Manco, Inc.

Entrant
Tenneco Packaging Ashland
Ashland, OH

Sub-Category
Office Equipment and Supplies

Division

Stationery, Office Supplies and Seasonal Goods / 143

Award
Silver

Title
TRENDÆ "Back to School" Prepack Pallet

Client
TRENDÆ Enterprises, Inc.

Entrant
Smyth Companies - Display Division
St. Paul, MN

Sub-Category
Stationery, Party Goods, Giftwrap, Disposable Writing

Division
Temporary

Award
Bronze

Title
"Little Gems Press" Spinner

Client
American Greetings

Entrant
American Greetings, Corp.
Cleveland, OH

Sub-Category
Greeting Cards

Division
Permanent

Award
Bronze

Title
Kensington Back to School

Client
Acco Brands, Inc.

Entrant
Great Northern Corporation
Racine, WI

Sub-Category
Office Equipment and Supplies

Division
Temporary

144 / Stationery, Office Supplies and Seasonal Goods

AWARD
Bronze

TITLE
Markers and Adhesives

CLIENT
Avery Dennison Office Products Worldwide

ENTRANT
Longview Fibre Display Group
Milwaukee, WI

SUB-CATEGORY
Stationery, Party Goods, Giftwrap, Disposable Writing

DIVISION
Temporary

AWARD
Bronze

TITLE
Gift Box Display

CLIENT
Avery Dennison Office Products Worldwide

ENTRANT
Longview Fibre Display Group
Milwaukee, WI

SUB-CATEGORY
Greeting Cards

DIVISION
Temporary

AWARD
Bronze

TITLE
Eastpak

CLIENT
Avery Dennison Office Products Worldwide

ENTRANT
Longview Fibre Display Group
Milwaukee, WI

SUB-CATEGORY
Stationery, Party Goods, Giftwrap, Disposable Writing

DIVISION
Temporary

Tobacco / 145

Award
Gold

Title
Camel CTS Program

Client
R. J. Reynolds Tobacco Co.

Entrant
Trans World Marketing
East Rutherford, NJ

Sub-Category
Cigarettes - Illuminated

Division
Permanent

Award
Gold

Title
Camel Bar Program
Permanent Display Units

Client
R. J. Reynolds Tobacco Co.

Entrant
Visual Marketing, Inc.
Chicago, IL

Sub-Category
Cigarettes - Illuminated

Division
Permanent

Award
Gold

Title
Camel 20-Pack Shadow Box

Client
R. J. Reynolds Tobacco Co.

Entrant
Chesapeake Display and
Packaging, Inc.
Winston-Salem, NC

Sub-Category
Cigarettes - Non-Illuminated

Division
Temporary

146 / Tobacco

AWARD
Silver

TITLE
Brown & Williamson Showcase System

CLIENT
Brown & Williamson Tobacco Corp.

ENTRANT
Consumer Promotions International
Mount Vernon, NY

SUB-CATEGORY
Cigarettes - Non-Illuminated

DIVISION
Permanent

AWARD
Silver

TITLE
General Cigar Counter Unit

CLIENT
General Cigar Corporation

ENTRANT
Smurfit-Stone Display Group
Sandston, VA

SUB-CATEGORY
Other Tobacco Products

DIVISION
Temporary

AWARD
Silver

TITLE
Doral CTS Buy Eight Get Two Free Floorstand

CLIENT
R. J. Reynolds Tobacco Co.

ENTRANT
Southland Packaging & Promotions and RJ Reynolds
Statesville, NC

SUB-CATEGORY
Cigarettes - Non-Illuminated

DIVISION
Semi-Permanent

AWARD
Silver

TITLE
Camel Mighty Tasty LifeStyles Standee

CLIENT
R. J. Reynolds Tobacco Co.

ENTRANT
Southland Packaging & Promotions and RJ Reynolds
Statesville, NC

SUB-CATEGORY
Cigarettes - Non-Illuminated

DIVISION
Temporary

Tobacco / 147

AWARD
Silver

TITLE
Doral CTS Program

CLIENT
R. J. Reynolds Tobacco Co.

ENTRANT
Trans World Marketing
East Rutherford, NJ

SUB-CATEGORY
Cigarettes - Illuminated

DIVISION
Permanent

AWARD
Silver

TITLE
Schimelpenninck Permanent
Cigar Merchandiser

CLIENT
Rothmans of Pall Mall Australia Ltd

ENTRANT
Reid Lalor Displays
Klirraween, Australia

SUB-CATEGORY
Other Tobacco Products

DIVISION
Permanent

AWARD
Bronze

TITLE
FrameMaster Illuminated Sign

CLIENT
Brown & Williamson Tobacco
Corp.

ENTRANT
United Displaycraft
Des Plaines, IL

SUB-CATEGORY
Cigarettes - Illuminated

DIVISION
Permanent

148 / Tobacco

Award
Bronze

Title
Premium Cigar Tube Venda Display

Client
Consolidated Cigar Corporation

Entrant
ImageWorks Display & Marketing Group
Winston-Salem, NC

Sub-Category
Other Tobacco Products

Division
Permanent

Award
Bronze

Title
Winston/Salem 20-Pack Counter Displays

Client
R. J. Reynolds Tobacco Co.

Entrant
Chesapeake Display and Packaging, Inc.
Winston-Salem, NC

Sub-Category
Cigarettes - Non Illuminated

Division
Temporary

Award
Bronze

Title
Doral CTS Neon with Changeable Message

Client
R. J. Reynolds Tobacco Co.

Entrant
Fallon Luminous Products Corporation
Spartanburg, SC

Sub-Category
Cigarettes - Illuminated

Division
Permanent

Award
Bronze

Title
Salem Slide Box 20/30 Pk Adj. Counter Display

Client
R. J. Reynolds Tobacco Co.

Entrant
ImageWorks Display & Marketing Group
Winston-Salem, NC

Sub-Category
Cigarettes - Non-Illuminated

Division
Semi-Permanent

Tobacco / 149

Award
Bronze

Title
Camel Twin Pack Replica Floorstand

Client
R. J. Reynolds Tobacco Co.

Entrant
Southland Packaging & Promotions and RJ Reynolds
Statesville, NC

Sub-Category
Cigarettes - Non-Illuminated

Division
Temporary

Award
Bronze

Title
Camel Ceiling Logo

Client
R. J. Reynolds Tobacco Co.

Entrant
Trans World Marketing
East Rutherford, NJ

Sub-Category
Cigarettes - Non-Illuminated

Division
Permanent

Award
Bronze

Title
UST Rooster & Copenhagen Penny Tray

Client
United States Tobacco Company

Entrant
Markson Rosenthal & Company
Englewood Cliffs, NJ

Sub-Category
Other Tobacco Products

Division
Semi-Permanent

150 / Transportation

AWARD
Gold

TITLE
Potenza Racing Tire Display

CLIENT
Bridgestone/Firestone Tire Sales Company

ENTRANT
Innovative Marketing Solutions, Inc.
Bensenville, IL

SUB-CATEGORY
Automotive Aftermarket

DIVISION
Permanent

AWARD
Gold

TITLE
Vision Blade New Product Rollout Promotion

CLIENT
First Brands Corporation

ENTRANT
Taurus Packaging and Display Corporation
Cherry Hill, NJ

SUB-CATEGORY
Automotive Aftermarket

DIVISION
Temporary

AWARD
Gold

TITLE
MOOG Gusher Bearing Counter Unit

CLIENT
Cooper Automotive Products

ENTRANT
New Dimensions Research Corporation
Melville, NY

SUB-CATEGORY
Automotive Aftermarket

DIVISION
Semi-Permanent

Transportation / 151

AWARD
Gold

TITLE
Goodyear Run-Flat Tire Demonstrator

CLIENT
Goodyear Tire & Rubber Company

ENTRANT
MCA Sign
Massillon, OH

SUB-CATEGORY
Automotive Aftermarket

DIVISION
Permanent

AWARD
Silver

TITLE
Harley-Davidson Graphic Frames

CLIENT
Harley-Davidson

ENTRANT
DCI Marketing
Milwaukee, WI

SUB-CATEGORY
Passenger Cars and Specialty Vehicles

DIVISION
Permanent

152 / Transportation

Award
Silver

Title
Bosch Platinum +4 Spark Plug Display

Client
Robert Bosch Corporation

Entrant
Innovative Marketing Solutions, Inc.
Bensenvill, IL

Sub-Category
Automotive Aftermarket

Division
Permanent

Award
Bronze

Title
Honda Rear Wing Spoiler Display

Client
American Honda

Entrant
Santa Cruz Industries
Santa Cruz, CA

Sub-Category
Automotive Aftermarket

Division
Permanent

Award
Bronze

Title
Suzuki Info Center &
Video Monitor Display

Client
American Suzuki Motor Corp.

Entrant
R/P Creative Sales, Inc.
Burbank, CA

Sub-Category
Passenger Cars and Specialty
Vehicles

Division
Permanent

Transportation / 153

AWARD
Bronze

TITLE
Bosch Wiper Blade Merchandiser

CLIENT
Robert Bosch Corporation

ENTRANT
Innovative Marketing Solutions, Inc.
Bensenville, IL

SUB-CATEGORY
Automotive Aftermarket

DIVISION
Permanent

AWARD
Bronze

TITLE
Power Jack

CLIENT
Atwood Mobile Products

ENTRANT
Longview Fibre Display Group
Milwaukee, WI

SUB-CATEGORY
Automotive Aftermarket

DIVISION
Temporary

AWARD
Bronze

TITLE
Mobil One Enhanced
Presence Program

CLIENT
Mobil Oil

ENTRANT
Trans World Marketing
East Rutherford, NJ

SUB-CATEGORY
Petroleum Products

DIVISION
Permanent

154 / Transportation

Award
Bronze

Title
Saab Freestanding Literature Display

Client
Saab Cars USA, Inc.

Entrant
DCI Marketing
Milwaukee, WI

Sub-Category
Passenger Cars and Specialty Vehicles

Division
Permanent

Award
Bronze

Title
Whistler 2x2 Floorstand

Client
Whistler Corporation

Entrant
Phoenix Display,
A Union Camp Company
West Deptford, NJ

Sub-Category
Automotive Aftermarket

Division
Permanent

MULTINATIONAL AWARDS CONTEST

The Multinational Contest recognizes the merchandising excellence of displays produced and placed outside of the United States, Europe and Japan.

156 / Multinational

Award
Gold

Title
Urge '98

Client
Coca-Cola Company

Entrant
Leo Burnett Foersteledd AS
Oslo, Norway

Sub-Category
Multinational

Division
Temporary

Award
Gold

Title
Tylenol Rotating Floor Display

Client
McNeil Consumer Products

Entrant
Point 1 Displays, Inc.
Montreal, Quebec, Canada

Sub-Category
Multinational

Division
Permanent

Award
Silver

Title
Neutrogena Deep Clean Floor Display

Client
Johnson & Johnson Canada, Inc,

Entrant
Point 1 Displays, Inc.
Montreal, Quebec, Canada

Sub-Category
Multinational

Division
Temporary

Multinational / 157

AWARD
Silver

TITLE
Exhibidor Papa Pringles

CLIENT
Procter & Gamble de Mexico, S.A. de C.V.

ENTRANT
RTC Mexico
Mexico

SUB-CATEGORY
Multinational

DIVISION
Permanent

AWARD
Silver

TITLE
MARS Lite Tower

CLIENT
Mars Confectionery of Australia

ENTRANT
Visy Displays,
A Division of Pratt Industries
Melbourne, Australia

SUB-CATEGORY
Multinational

DIVISION
Temporary

AWARD
Silver

TITLE
Semi-Permanent Cigarettes,
Non-Illuminated

CLIENT
Rothmans of Pall Mall,
New Zealand

ENTRANT
Boyed Signs & Displays NZ Ltd
Paraparaumu, Wellington,
New Zealand

SUB-CATEGORY
Multinational

DIVISION
Permanent

158 / Multinational

AWARD
Silver

TITLE
Fudge Mega Display

CLIENT
Sabre Corporation

ENTRANT
Visy Displays
A Division of Pratt Industries
North Sydney, Australia

SUB-CATEGORY
Multinational

DIVISION
Semi-Permanent

AWARD
Bronze

TITLE
Dad's Multishelf Display

CLIENT
Christie Brown & Co., Ltd.

ENTRANT
Protagon Display Inc.
Scarborough, ON, Canada

SUB-CATEGORY
Multinational

DIVISION
Temporary

AWARD
Bronze

TITLE
Sustagen Silent Seller II

CLIENT
Bristol-Myers Squibb Australia Pty. Ltd.

ENTRANT
Reid Lalor Displays
Kirrawee, Australia

SUB-CATEGORY
Multinational

DIVISION
Semi-Permanent

Multinational / 159

Award
Bronze

Title
Coca Cola Christmas Together Always

Client
Coca-Cola South Pacific

Entrant
Ace Print & Display PTY LTD
Revesby, Australia

Sub-Category
Multinational

Division
Temporary

Award
Bronze

Title
Modulo Refrescante Contour

Client
Industria Embotelladora de Mexico SA DE CV

Entrant
Plastival
Guadalajara, Jalisco, Mexico

Sub-Category
Multinational

Division
Permanent

Award
Bronze

Title
Gold Max Floor Display

Client
Kodak Canada Inc.

Entrant
Protagon Display Inc.
Scarborough, Ontario, Canada

Sub-Category
Multinational

Division
Temporary

160 / Multinational

AWARD
Bronze

TITLE
Vitavive Floor Display

CLIENT
L'Oréal Canada

ENTRANT
Point 1 Displays, Inc.
Montreal, Quebec, Canada

SUB-CATEGORY
Multinational

DIVISION
Temporary

AWARD
Bronze

TITLE
SKECHERS USA Concept Shop

CLIENT
Skechers USA

ENTRANT
United Displaycraft
Des Plaines, IL

SUB-CATEGORY
Multinational

DIVISION
Permanent

AWARD
Bronze

TITLE
24 Piece Sunglass Stand

CLIENT
Spy Optics N.Z. Ltd.

ENTRANT
The Display Group
Auckland, New Zealand

SUB-CATEGORY
Multinational

DIVISION
Permanent

SALES PROMOTION AWARDS CONTEST

The Sales Promotion Contest recognizes the excellence of a display or promotion from anywhere in the world that was used in conjunction with at least two additional sales promotion techniques.

162 / Sales Promotion

AWARD
Gold

TITLE
Miller Lite Football

CLIENT
Miller Brewing Company

ENTRANT
Miller Brewing Company
Milwaukee, WI

SUB-CATEGORY
National

DIVISION
National

AWARD
Gold

TITLE
Chocolate Milk Display

CLIENT
Sefton

ENTRANT
Pride Container/Display Graphics LLC.
Chicago, IL

SUB-CATEGORY
Regional

DIVISION
Regional

Sales Promotion / 163

AWARD
Silver

TITLE
Nantucket Promotion

CLIENT
Hunter Douglas, Inc.

ENTRANT
Thomson-Leeds Company, Inc.
New York, NY

SUB-CATEGORY
Regional

DIVISION
Regional

AWARD
Silver

TITLE
Rolling Rock "Free Works of Art" Promotion

CLIENT
Labatt USA Inc.

ENTRANT
The Marketing Continuum, Inc.
Dallas, TX

SUB-CATEGORY
National

DIVISION
National

AWARD
Bronze

TITLE
Harley-Davidson Fuel Up for 95th Promotion

CLIENT
Harley-Davidson

ENTRANT
DCI Marketing
Milwaukee, WI

SUB-CATEGORY
National

DIVISION
National

TECHNICAL ACHIEVEMENT AWARDS

POPAI's Technical Awards recognize engineering excellence and the innovative use of materials in a P-O-P design.

Technical / 165

AWARD
Gold

TITLE
Bell Atlantic Mobile Interactive Display

CLIENT
Bell Atlantic Nynex Mobile

ENTRANT
Telescan Systems Inc.
Burlingame, CA

SUB-CATEGORY
Interactive Technology

DIVISION
Permanent

AWARD
Silver

TITLE
Excalibur Gold Interactive P-O-P Display

CLIENT
Omega Research & Development

ENTRANT
Telescan Systems Inc.
Burlingame, CA

SUB-CATEGORY
Interactive Technology

DIVISION
Permanent

AWARD
Gold

TITLE
Godzilla Spectacular Rain Display

CLIENT
Columbia Pictures

ENTRANT
Drissi Advertising, Inc.
Los Angeles, CA

SUB-CATEGORY
Miscellaneous Technology

DIVISION
Temporary

166 / Technical

AWARD
Bronze

TITLE
Godzilla Polar Motion Display

CLIENT
Columbia Pictures

ENTRANT
Drissi Advertising, Inc.
Los Angeles, CA

SUB-CATEGORY
Miscellaneous Technology

DIVISION
Temporary

AWARD
Bronze

TITLE
Coors Light Changing Label Lighted Sign

CLIENT
Coors Brewing Company

ENTRANT
The Integer Group
Lakewood, CO

SUB-CATEGORY
Illumination Technology

DIVISION
Permanent

Technical / 167

AWARD
Gold

TITLE
Armstrong Pro-20 Display - Waterfall Section

CLIENT
CDA Industries, Inc.

ENTRANT
Tri-Star Plastics
Scarborough, Ontario, Canada

SUB-CATEGORY
Plastic Processes

DIVISION
Permanent

AWARD
Gold

TITLE
Thermasilk Pre-loaded Floor Display

CLIENT
Lever Pond's Canada

ENTRANT
Techno P.O.S., Inc.
Anjou, Quebec, Canada

SUB-CATEGORY
Miscellaneous Processes

DIVISION
Temporary

AWARD
Gold

TITLE
TSV 'Spike' Backbar Display

CLIENT
Newday Communications Inc.

ENTRANT
The Key Display Group
Teaneck, NJ

SUB-CATEGORY
Miscellaneous Processes

DIVISION
Permanent

168 / Technical

AWARD
Silver

TITLE
Chrysler Showcase Interactive Kiosk

CLIENT
Chrysler Division, Chrysler Corporation

ENTRANT
Visual Productions, Inc.
Troy, MI

SUB-CATEGORY
Plastic Processes

DIVISION
Permanent

AWARD
Silver

TITLE
Coors Light 3-D Pool Table Lamp

CLIENT
Coors Brewing Company

ENTRANT
The Integer Group
Lakewood, CO

SUB-CATEGORY
Miscellaneous Processes

DIVISION
Permanent

AWARD
Silver

TITLE
Nike Vision & Timing

CLIENT
Nike, Inc.

ENTRANT
RTC Industries, Inc.
Rolling Meadows, IL

SUB-CATEGORY
Plastic Processes

DIVISION
Permanent

Technical / 169

AWARD
Silver

TITLE
Project TRIO

CLIENT
Whitehall-Robins Company

ENTRANT
Smurfit-Stone Display Group
Sandston, VA

SUB-CATEGORY
Miscellaneous Processes

DIVISION
Temporary

AWARD
Bronze

TITLE
CIBA Vision Focus Toric

CLIENT
CDA Industries, Inc.

ENTRANT
Tri-Star Plastics
Scarborough, ON, Canada

SUB-CATEGORY
Plastic Processes

DIVISION
Permanent

AWARD
Bronze

TITLE
Original Coors Metal
Pool Table Lamp

CLIENT
Coors Brewing Company

ENTRANT
The Integer Group
Lakewood, CO

SUB-CATEGORY
Wire and Metal Processes

DIVISION
Permanent

AWARD
Bronze

TITLE
CIBA Vision New Vues

CLIENT
CDA Industries, Inc.

ENTRANT
Tri-Star Plastics
Scarborough, ON, Canada

SUB-CATEGORY
Plastic Processes

DIVISION
Permanent

170 / Technical

AWARD
Bronze

TITLE
Pack 'N' Stack Tray Stacker

CLIENT
Hershey Foods Corporation

ENTRANT
Triangle Container Corporation
Philadelphia, PA

SUB-CATEGORY
Miscellaneous Processes

DIVISION
Temporary

AWARD
Bronze

TITLE
FedEx Drop Box

CLIENT
Federal Express

ENTRANT
RTC Industries, Inc.
Rolling Meadows, IL

SUB-CATEGORY
Plastic Processes

DIVISION
Permanent

AWARD
Bronze

TITLE
Millennium Falcon

CLIENT
Toys 'R' Us/Hasbro/Galoob

ENTRANT
RTC Industries, Inc.
Rolling Meadows, IL

SUB-CATEGORY
Plastic Processes

DIVISION
Permanent

Technical / 171

AWARD
Silver

TITLE
Tony & Tina Nail, Hair
& Lip Merchandisers

CLIENT
Tony & Tina

ENTRANT
The Royal Promotion
Group, Inc.
New York, NY

SUB-CATEGORY
Metal

DIVISION
Permanent

AWARD
Silver

TITLE
L'Oréal Colour Xperience
Floor Display

CLIENT
Cosmair Canada Inc.

ENTRANT
Techno P.O.S., Inc.
Anjou, Quebec, Canada

SUB-CATEGORY
Corrugated and Paper

DIVISION
Temporary

AWARD
Bronze

TITLE
Smashbox Full-line Cosmetic Tester Displays

CLIENT
Smashbox

ENTRANT
The Royal Promotion Group, Inc.
New York, NY

SUB-CATEGORY
Corrugated and Paper

DIVISION
Permanent

AWARD
Bronze

TITLE
1997 Christmas Standee

CLIENT
M&M/MARS

ENTRANT
Smurfit-Stone Display
Group
Sandston, VA

SUB-CATEGORY
Miscellaneous Processes

DIVISION
Temporary

INDEX OF DISPLAYS

20th Century Fox, 44
Abbott Laboratories Canada Inc., 82, 85
Acco Brands, Inc., 143
Accumark Promotions for Warner-Lambert Canada, 83
Acorn, 93
Advance Publishers, 132
Akzo Nobel, 93
Allied Domecq Spirits, USA, 28
American Greetings, 142, 143
American Honda, 152
American Suzuki Motor Corp., 152
Andrew Jergens, 76
Andrew Jergens, Div. of KAO, 77
Anheuser-Busch, Inc., 16, 17, 19, 20
Applause Inc./Justman Packaging, 131
The AT-A-GLANCE Group, 141
Atwood Mobile Products, 153
Audi of America, Inc., 98
Auntiie Anne's, 119
Avery Dennison Office Products Worldwide, 144
Bacardi Martini, 25, 29
Baldwin Hardware Corporation Lighting Center, 94
Barnes & Noble, 135
Barton Beers Ltd. 17
Beautycology, Inc. 72
Bell Atlantic Nynex Mobile, 165
Best Buy Stores, 52
BIC Corporation, 141
Big Idea Productions, 131
Bi-Lo Stores, Inc., Subsidiary of Ahold USA, 121
Blau Marketing, 46
Bose Corporation, 50
Boston Beer Company, 18, 20
Brach & Brock Confections, 122
Braun, 82
Braun Canada Ltd., 85
Bridgestone/Firestone Tire Sales Company, 150
Bristol-Myers Squibb Australia Pty. Ltd., 158
Brown & Williamson Tobacco Corp., 146, 147
Brown-Forman Beverages Worldwide, 29
Buena Vista Home Entertainment, 50, 51
California Suncare, 72, 73
Calvin Klein, 62
The Campbell Group Ltd., 24
Casio, 107

Canandaigua Wine Company, 26
CDA Industries, Inc., 167, 169
Chanel, 37, 63
Chateau Ste. Michelle Winery, 29
Christiania Bank & Kreditkasse, 120
Christie Brown & Co., Ltd., 158
Chrysler Division, Chrysler Corporation, 168
Circuit City Stores, Inc., 116
CKS Partners, 46, 51
Coca-Cola Amatil, 123
The Coca-Cola Company, 126, 130, 156
Coca-Cola South Pacific, 159
Coca-Cola USA, 123, 125
Colgate-Palmolive Company, 83
Columbia Pictures, 165, 166
Consolidated Cigar Corporation, 148
Cooper Automotive Products, 150
Coors Brewing Company, 18, 20, 21, 166, 168, 169
Corning Consumer Products Company, 94
Coronado Paint Company, 90
Cosmair Canada Inc., 171
Cosmair, Inc., 38, 63, 77
Coty Canada, 63
Coty, Inc., 60, 61, 65
Cover Girl-Procter and Gamble, 35, 39
Creative Alliance, 30
D.K. Publishing, Inc., 131, 136
Dal-Tile, 89
DaySpring Cards, 133, 142
Dermotological Sciences Inc., 74
DeWalt Division - Black & Decker, 91
The Dial Corp., 83, 84
Diamond Group, 26
Disney Consumer Products and Mattel, 132
DMC Corporation, 101
Draft Worldwide, 30
Dr. Pepper, 121, 123
Dunlop Maxfli Sports Corporation, 136
Duracell U.S.A., 133, 136, 137
E & J Gallo Winery, 10, 25
Eastpak Corporation, 100
Electronic Arts, 44, 52
Elizabeth Arden, 63, 64
Epson America, 46, 102
Estée Lauder Companies, 64
Estée Lauder, Inc., 35, 37, 39, 40, 60, 62, 64, 74
Equity Marketing, Inc., 137
Exide Corporation, 98
Federal Express, 170
Fempro Inc. of Cascades, 85

Fender Musical Instruments, 107
First Brands Corporation, 150
Flair Communications, 31
Frito-Lay, Inc., 121, 122, 123, 124, 126
General Cigar Corporation, 146
General Nutrition Corp., 116
Gillette Canada, 72
The Gillette Company, 80
The Gillette Company NA, 73, 80
GMSPO, 120
Golden Books Publishing, 133
Goodtimes Entertainment, 47
Goodyear Tire & Rubber Company, 151
Great Brands of Europe, Inc., 127
H. Reitman and Company, 94
H.E. Butt, 122
Harley-Davidson, 151, 163
Havas Interactive, Inc., 44
Helene Curtis Division of Unilever, 84
Hershey Chocolate USA, 124
Hershey Foods Corporation, 170
Hershey North America, 127
Hillshire Farms & Kahns, 68
Hiram Walker & Sons, Inc., 27, 31
HI-TEC Sports USA, Inc., 102
Hormel Foods Corporation, 65
Horshino, U.S.A., 52
Hunter Douglas, Inc., 95, 163
IAMS, 68
Industria Embotelladora de Mexico SA de CV
Intel Corporation, 52, 53, 99
The Integer Group-Dallas, 105
J.A. Henckels Open Stock Company, 91
Jim Beam Brands, 32
John B. Sanfilippo & Son, Inc., 127
Johnson & Johnson, 86
Johnson & Johnson Canada Inc., 156
Johnson & Johnson Consumer Products Company, 74
Johnson & Johnson - Merck Consumer Pharm. Co., 84
Johnson Level and Tool, 95
JVC Company of America, 45
Kayser-Roth Corporation, 102
Keene Communications, 47
KMart, 107, 115
Kodak Canada Inc., 137, 159
Kraft Foods, Inc., 69, 124, 128
Kusin Gurwitch Cosmetics, LLC., 40
Labatt USA, 16, 21, 163
Langeveld Bulb Company, 95

Index / 173

The Learning Company, 57, 58
Lever Pond's Canada, 75, 167
Lindt & Spruneli, 128
Lipton, Inc. 65, 66, 69
The Little Tikes Company, 139
Logitech, 53
L'Oréal, 74
L'Oréal Canada, 77, 78, 160
L'Oréal, Inc., 41
L'Oréal Retail Division, 11, 35, 36, 37, 40, 78
Louisville Hockey, 134
Lowes Companies, Inc., 91
Lowe's Home Improvement Warehouse, 96
Lyrick Studios, 45, 53
M. Shanken Communications, Inc., 134
Manco, Inc., 92, 142
Mango Graphics, 96
Maple Leaf Bakery, 66
The Marketing Continuum Inc., 24
Mars Confectionery of Australia, 157
Mattel, Inc., 138
Mattel Toys, 134
Maybeline Canada, 41
Maybeline, Inc. 41
McCann Communications, 108
McCormick & Company, 69
MCI/World Com, 100
McNeil Consumer Healthcare, 86
McNeil Consumer Products, 12, 156
MGM/UA Pictures, 54
Microsell Solutions Telecommunications, 103
Microsoft Corporation, 45, 47
Miller Brewing Company, 13, 16, 17, 18, 19, 21, 22, 23, 24, 162
Minami International Corporation, 96
Minwax, 92
M&M/Mars, 141, 171
Mobil Oil, 153
The Monet Group, Inc., 106
Motorola, 108
Mott's USA, 67
Nabisco Biscuit Company, 128
Nabisco Ltd., 67, 125, 128
Nabisco USFG Merchandising Department, 66
Nestle Food Company, 125, 129
New Balance, 100
Newday Communications Inc., 167
Nike, 109
Nike, Inc., 103, 168
Nintendo of America, Inc., 48, 54, 99, 117
Ocean Spray, 129
Omega Research & Development, 165
Omnipoint Communications, Inc., 104, 109
Oral-B Laboratories, 82
Osram Sylvania, 97
Otis Spunkmeyer, 67, 70

Outer Circle Products, Ltd., 110
Panasonic Consumer Electronics, 49
Paramount Pictures, 55
Paramount Home Video, 49, 55
Parfums de Couer, Ltd., 79
Parfums Givenchy, 41
Pepperidge Farm, 129
Pepsi-Cola Company, 130
Philips Consumer Electronics, 55
The Pillsbury Company, 68
Pilot Pen France, 101
Plank Road Brewery, 19
Playtex Products, Inc., 79
Polygram Entertainment, 56
Pontiac-GMC, 98
Power Tan Corporation, 79
PriceWeber Marketing Communications, Inc., 32
Primordial, LLC, 138
Procter & Gamble, 87
Procter & Gamble Co., 42, 70, 89, 99, 125
Procter & Gamble de Mexico, S.A. de C.V., 157
Procter & Gamble GMBH, 42
Quickie Manufacturing Company, 89
R.J. Reynolds Tobacco Co., 14, 145, 146, 147, 148 149
Radio Shack, 116
Rainbird, 97
Random House, Inc., Children's Publishing, 138
Rapid de Venezuela, 86
Reckitt & Colman, 70, 71
Revlon, Inc. 36, 38, 43, 80
Riviera Concepts, Inc., 61
RNR Inc., 134
Robert Bosch Corporation, 152, 153
Rothmans of Pall Mall Australia Ltd., 147
Rothmans of Pall Mall, New Zealand, 157
Saab Cars USA, Inc., 154
Sabre Corporation, 158
Sandstrom Design, 110
Sara Lee, 110
Schering-Plough, 73
Schering Plough Health Care Products, 87
Schick Shaving Products Group, 75
Schieffelin & Somerset Co., 26, 27, 28, 33
Schwarz Worldwide, 116
Sea & Ski, 75
Sears Canada, 117
Sefton, 162
Seiko Corporation of America, 111
Seiko/Pulsar, 104
Senco Fastening System, 97
Sherwin-Williams, 92
Shimano American Corporation, 139
Siebel Marketing Group, 33

Simplicity Manufacturing Company, 90
Skechers USA, Inc., 101, 111, 112, 160
Sky Latin America L.L.C., 56
Skyy Vodka Spirits, Inc., 34
Smashbox, 171
Smashbox Studio Cosmetics, 38
Sony DCR-PCI, 104
Sony Electronics, Inc., 56, 112
Sony Music Distribution, 57
Sony Pictures, 49
Sony PMC of America, 112
Spalding Sports Worldwide, 135
Sprint, 105, 112
Sprint Corporation, 113
Sprint PCS, 105, 113
Spy Optics N.Z. Ltd., 160
Star-Kist Foods, Inc., Heinz Pet Products, 68, 71
Statoil Marketing Norway, 119
Tabata USA, Inc., 139
Target Stores, 115
Tarkett, Inc., 90
Teledyne Water Pik, 93
Telestar Interactive, 98
Tesco Stores PLC, 43
Thomson Consumer Electronics, 58
Timberland Packs and Travel Gear, 113
Titleist/Foot Joy Worldwide, 135
Tommy Hilfiger Eyewear, 114
Tony & Tina, 36, 75, 171
Totes, 114
Toys 'R' Us/Hasbro/Galoob, 170
TRENDAE Enterprises, Inc., 143
Tru-Fit, 85
UDV North America, 34
Unilon, 113
Sprint PCS, 105, 113
Spy Optics N.Z. Ltd., 160
Star-Kist Foods, Inc., Heinz Pet Products, 68, 71
Statoil Marketing Norway, 119
Tabata USA, Inc., 139
Tarkett, Inc., 90
Teledyne Water Pik, 93
Telestar Interactive, 98
Tesco Stores PLC, 43
Thomson Consumer Electronics, 58
Timberland Packs and Travel Gear, 113
Titleist/Foot Joy Worldwide, 135
Tommy Hilfiger Eyewear, 114
Tony & Tina, 36, 75, 171
Totes, 114
Toys 'R' Us/Hasbro/Galoob, 170
TRENDAE Enterprises, Inc., 143
Tru-Fit, 85
UDV North America, 34
Unildwide, Inc., 106
The Worldwide Company, 118
Worth, Inc., 132
Wunderman Cato Johnson, 119, 120
Yamaha Corporation of America, 59
Yankee Publishing Co. Inc., 140

The Visual Reference Library
of Architecture and Design

Visit

www.visualreference.com